Rosemary Waller 1993

THE
Artful
Kitten

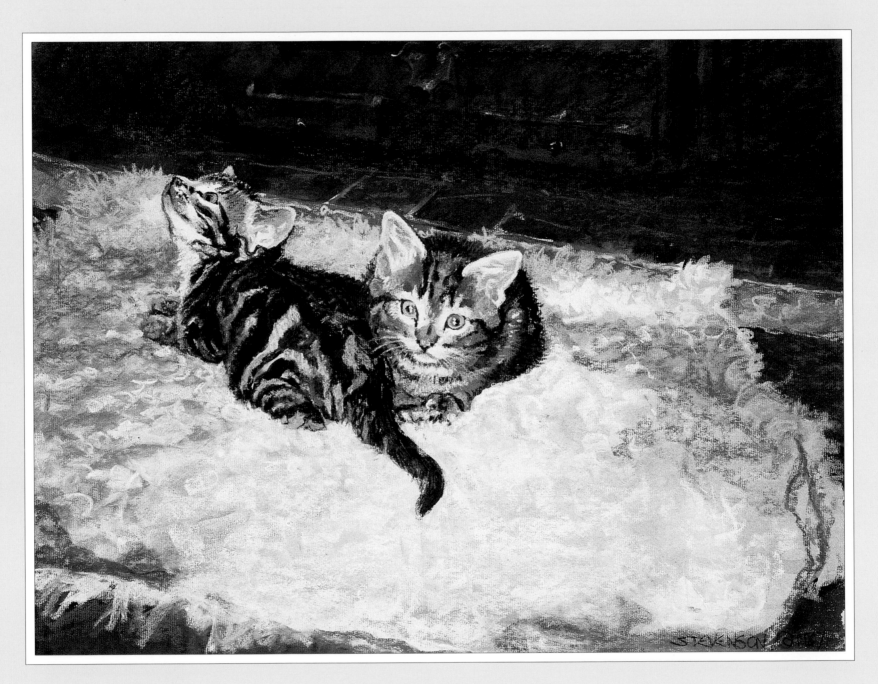

SURPRISED ON THE RUG
Wendy Stevenson

THE
Artful
Kitten

HONOR HEAD

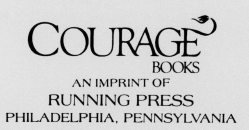

COURAGE
BOOKS
AN IMPRINT OF
RUNNING PRESS
PHILADELPHIA, PENNSYLVANIA

A QUARTO BOOK

Copyright © 1993
Quarto Publishing plc

9 8 7 6 5 4 3 2 1

Digit on the right indicates the number of this printing.

Library of Congress Cataloging-in-Publication 93-70600

ISBN 1-56138-328-7

This book was designed and produced by
Quarto Publishing plc
6 Blundell Street
London N7 9BH

Publishing Director *Janet Slingsby*

Art Director *Moira Clinch*
Senior Art Editor *Amanda Bakhtiar*
Designer *Jane Parker*
Senior Editor *Honor Head*
Picture Researcher *Mandy Little*

Typeset in Great Britain by Angel Graphics, London, England
Manufactured in Hong Kong by Regent Publishing Services Ltd.
Printed in Hong Kong by Leefung-Asco Printers Limited

First published in the United States
by Courage Books, an imprint of
Running Press Book Publishers
125 South Twenty-second Street
Philadelphia, Pennsylvania 19103

CONTENTS

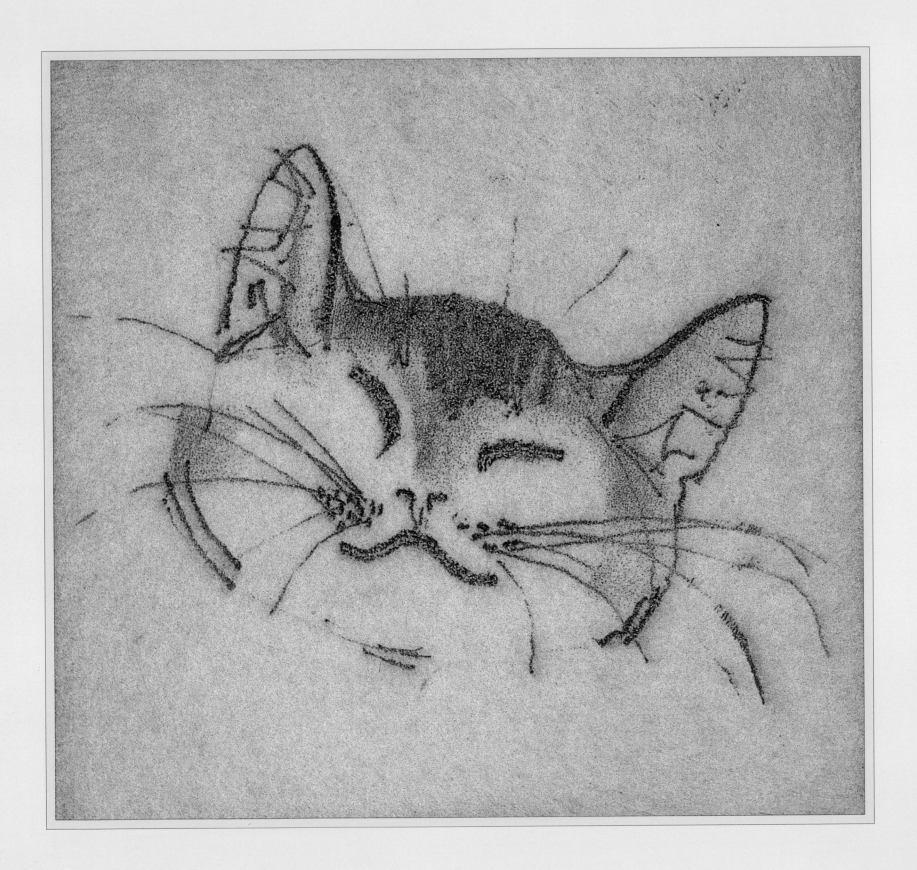

INTRODUCTION

Kittens are cute, cuddly . . . and totally irresistible. As the British poet William Cowper (1731-1800) wrote to his cousin: "I have a kitten, my dear, the drollest of all creatures that ever wore a cat's skin. Her gambols are not to be described and would be incredible if they could. . .".

You don't even have to be a kitten owner, however, to fall victim to a kitten's unique charm, delight in its innocent playfulness, be beguiled by its trusting purring, or succumb to its wide-eyed seductive pleading. There's just something about a kitten that gives it an appeal all of its own. And why not? We're only human, after all. It's only natural that such innocent bundles of fun should find their way into our hearts.

In pictures and words, this book is a vivid record of all the varied moods and facets of kittenhood. You'll see, for instance, kittens playing unselfconsciously, while their proud mother looks on; kitten comics and their delightfully mischievous, totally unpredictable pranks and tricks; kittens enjoying a saucer of fresh milk; kittens making friends, nose to nose, with their siblings; kittens exploring the world around them; and, of course, kittens purring contentedly in the arms of their human owners. Not only are the pictures appealing and inspiring in themselves; each one is also accompanied by an apposite poem or prose extract that sums up the subject and spirit of the illustration.

What you have in your hands, in short, is a treasury of kittenhood that is as irresistible in its appeal as is a kitten itself. Read on – perhaps with your own kitten in your lap – and enjoy.

MANX KITTEN
Julian Williams
. .

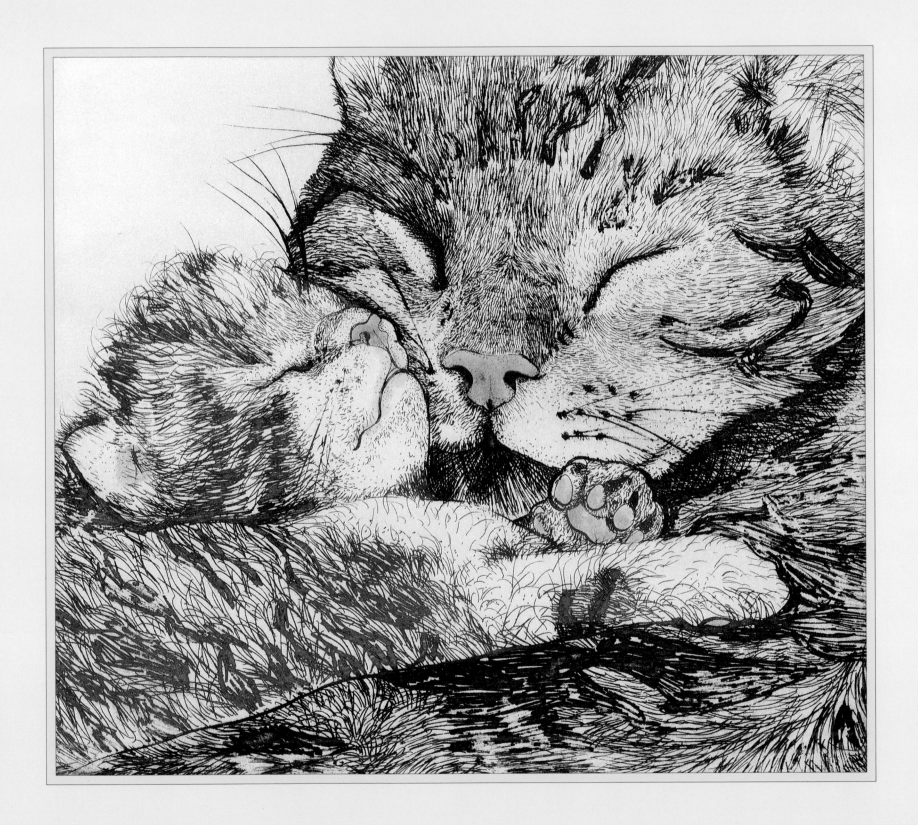

Family Portraits

The word "blissful" always suggests to
me the expression of a cat who has
given birth to her kittens.

Sidney Denham

THE CAT'S WHISKERS
Barbara Zalecki

Pussycat, wussicat, with a white foot,
When is your wedding and
I'll come to it.
The beer's to brew, and the
bread's to bake,
Pussycat, wussicat, don't be late.

ANONYMOUS

TWO KITTENS WITH BOWS
Esther Walton

If they are content, their contentment is absolute; and our jaded and wearied spirits find a natural relief in the sight of creatures whose little cups of happiness can so easily be filled to the brim.

AGNES REPPLIER

KITTENS
Susan Whelan
.

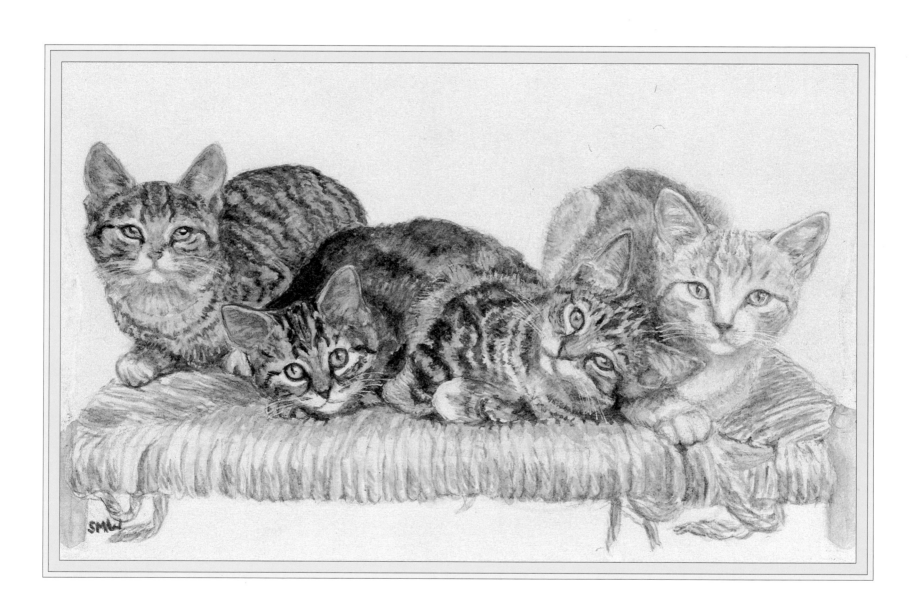

I have a kitten, my dear, the drollest of all creatures that ever wore a cat's skin. Her gambols are not to be described, and would be incredible, if they could. In point of size she is likely to be a kitten always, being extremely small for her age, but time, I suppose, that spoils everything, will make her also a cat. You will see her I hope before that melancholy period shall arrive, for no wisdom that she may gain by experience and reflection hereafter will compensate the loss of her present hilarity.

WILLIAM COWPER

KITTENS PLAYING
(Artist unknown)

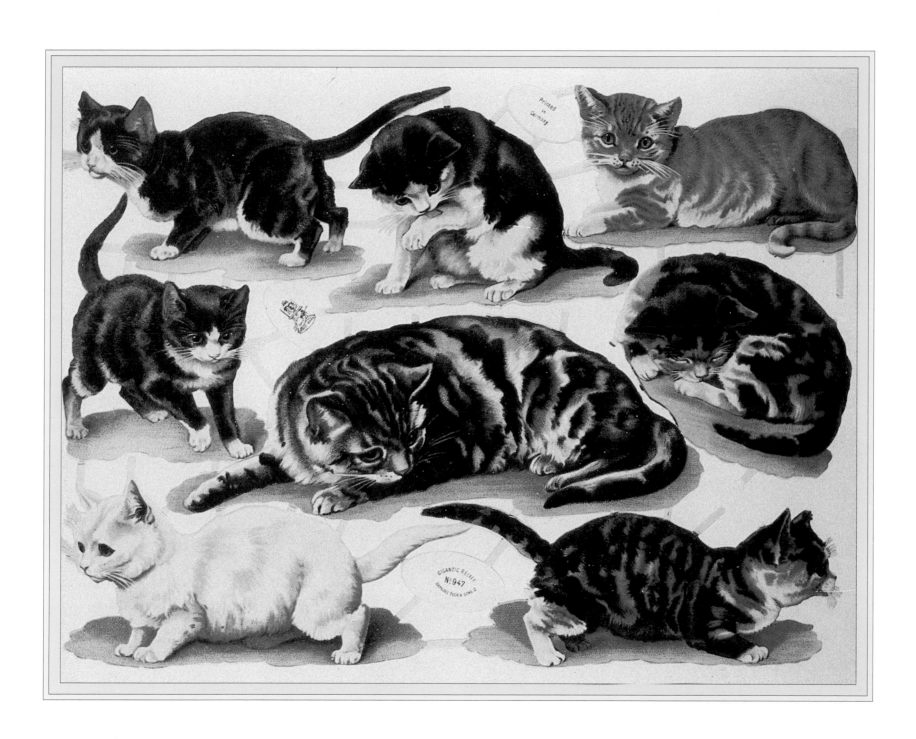

*N*othing's more playful than
a young cat, nor more grave than an old one.

THOMAS FULLER

MOTHER WITH YOUNG KITTENS
Madame H. Ronner

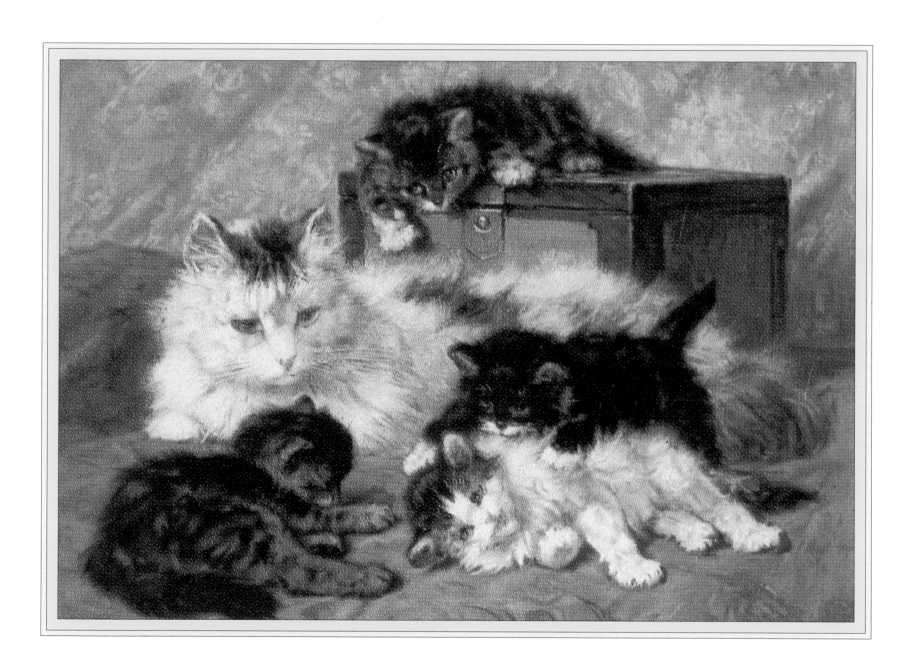

Four little Persians, but only one looked in my direction. I extended a tentative finger and two soft paws clung to it. There was a contented show of purring, I suspect on both our parts.

GEORGE FREEDLEY

CREAM PERSIAN
Ceramic design for Royal Worcester plate

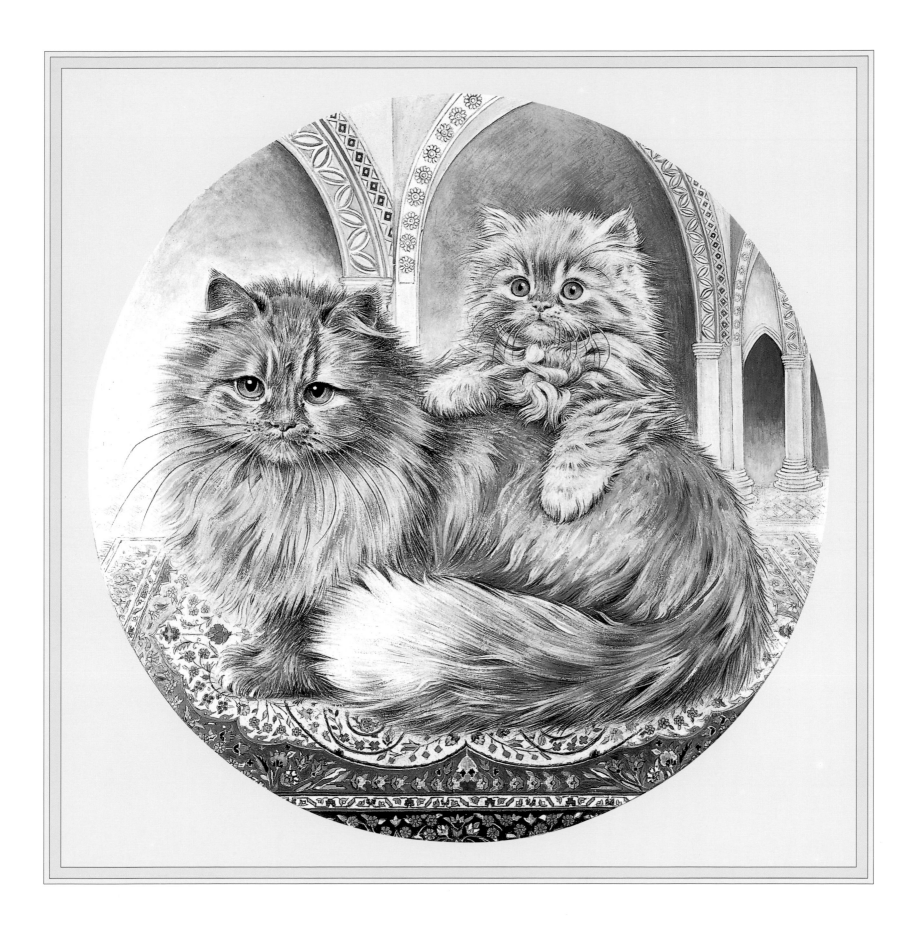

When Human Folk at Table eat,
A Kitten must not mew for meat,
Or jump to grab it from the Dish,
(*Unless it happen to be fish*).

ANONYMOUS
"The Whole Duty of Kittens"

FAMILY MATTER
Louis Wain

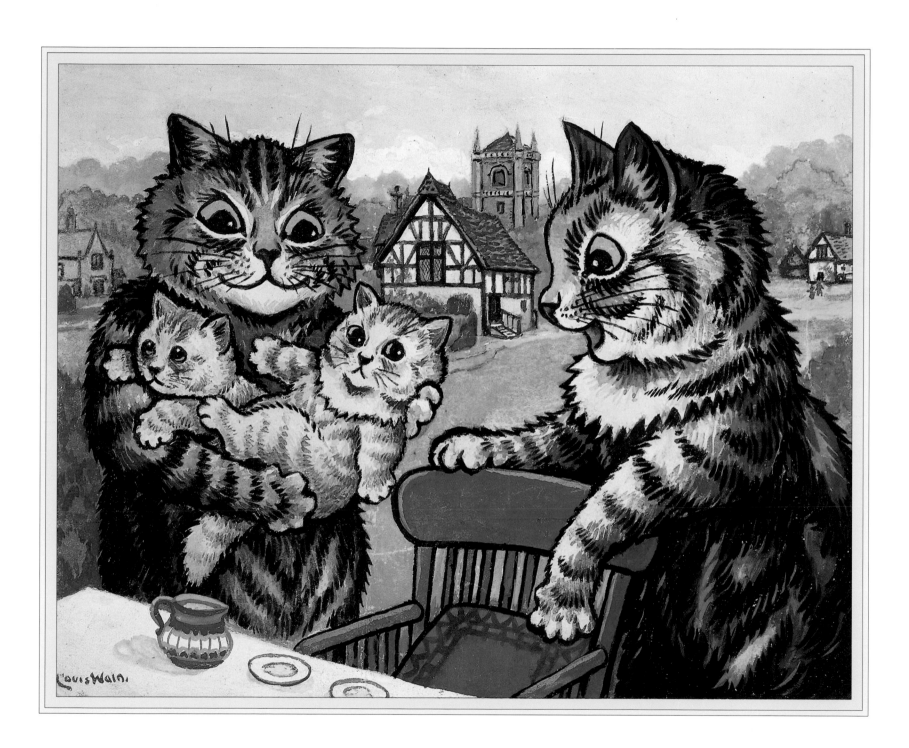
Louis Wain.

The worth of a kitten from the night it is kittened until it shall open its eyes, is a legal penny. And from the time that it shall kill mice, twopence. And after it shall kill mice, four legal pence; and so it always remains.

THE VENDOTIAN CODE, WALES, 10TH CENTURY

EYES JUST OPEN
Wendy Stevenson

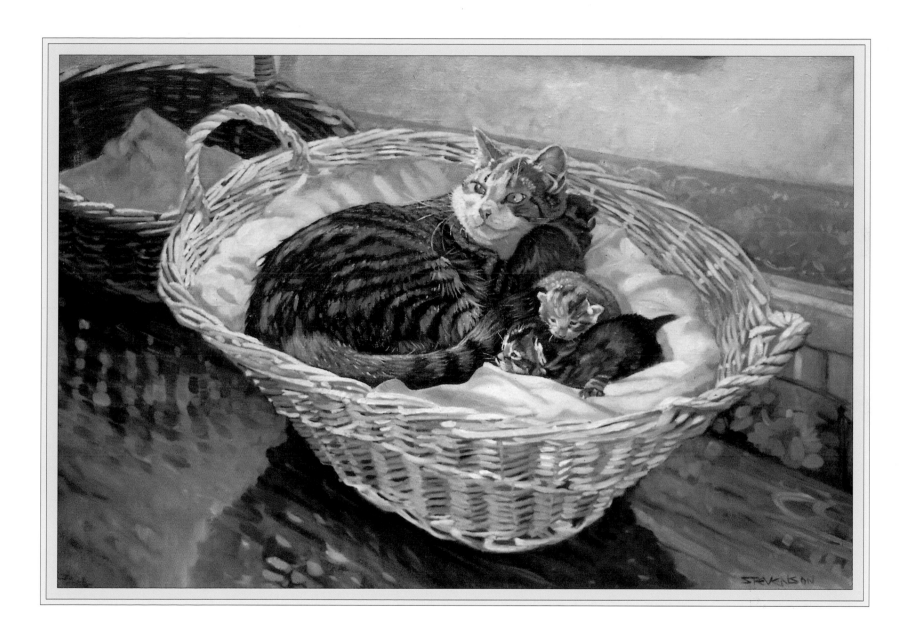

A cat with kittens is a small lioness.

SARAH B. WISTER

MOTHER CAT
Karin Van Heerden

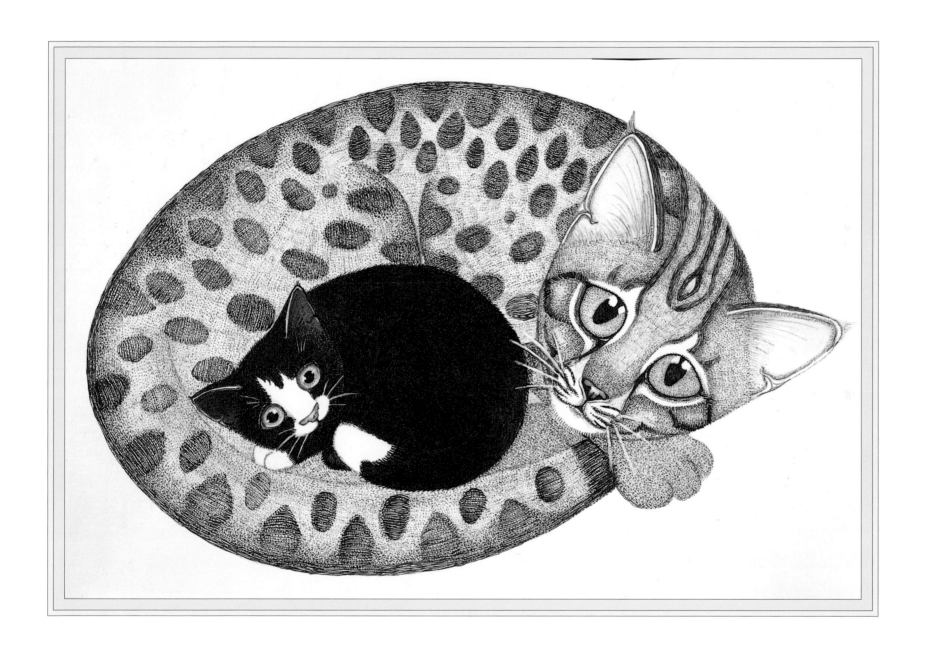

*W*e remember being much amused with seeing a kitten manifestly making a series of experiments upon the patience of its mother – trying how far the latter would put up with positive bites and thumps. The kitten ran at her every moment, gave her a knock or a bite of the tail; then ran back again to recommence the assault. The mother sat looking at her, as if betwixt tolerance and admiration, to see how far the spirit of the family was inherited by her sprightly offspring.

LEIGH HUNT
From "The Cat By The Fire"

PLAYING WITH MOTHER
Horatio H. Couldery

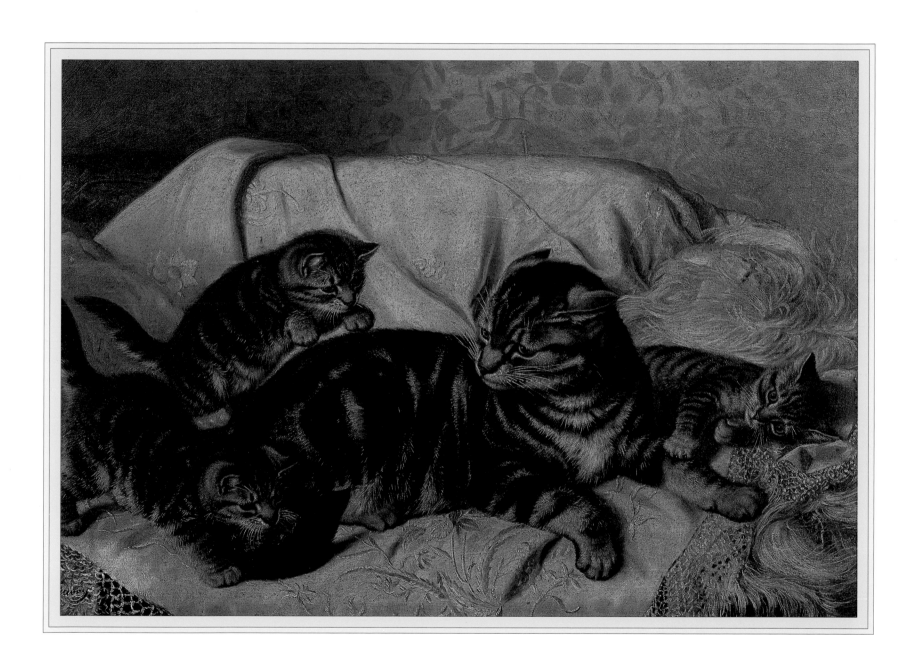

Three little kittens
They lost their mittens,
And they began to cry,
Oh, mother dear,
We sadly fear
Our mittens we have lost.
What! lost your mittens,
You naughty kittens!
Then you shall have no pie.
Mee-ow, mee-ow, mee-ow.
No, you shall have no pie.

Nursery rhyme

BATH TIME
Adrienne Lester
.

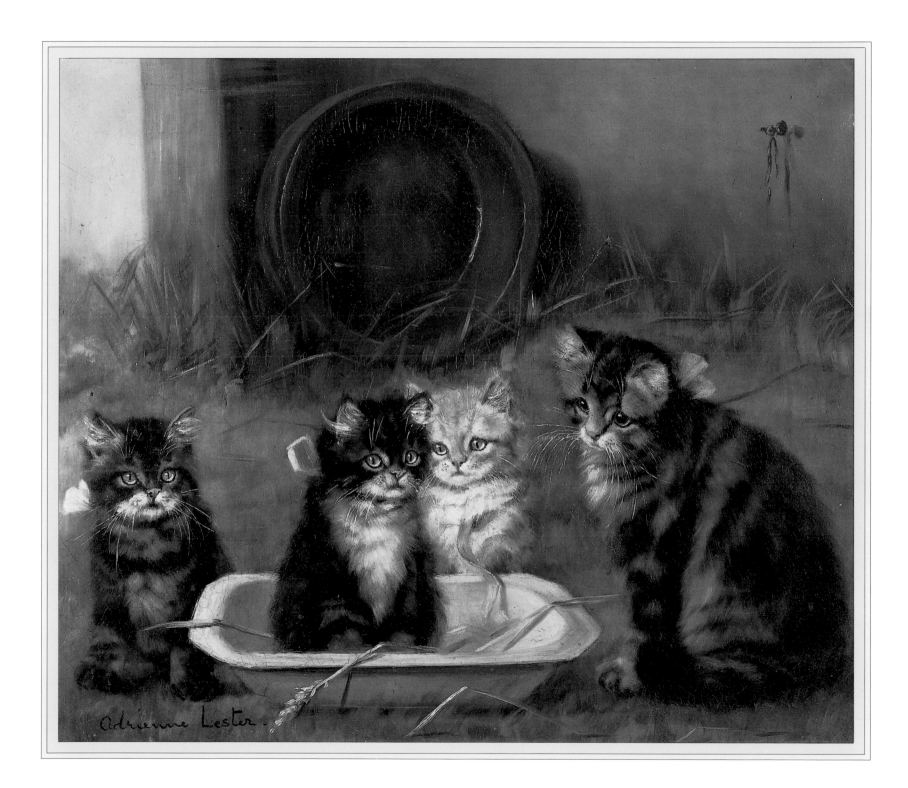

Adrienne Lester.

*W*hen food mysteriously goes,
The chances are that pussy knows
More than she leads you to suppose.

And hence there is no need for you,
If Puss declines a meal or two,
To feel her pulse and make ado.

ANONYMOUS

PLAYING WITH THE KITTENS
Edith F. Grey

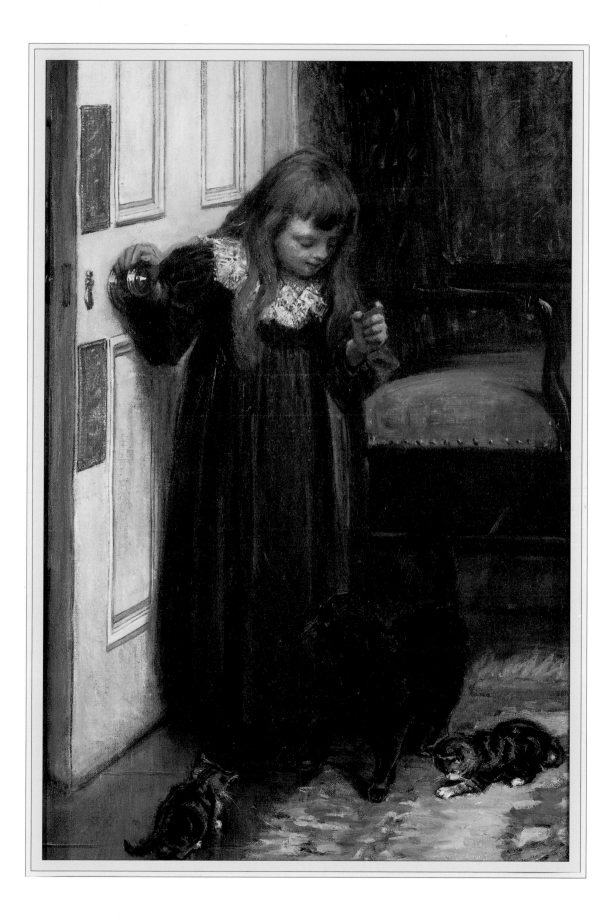

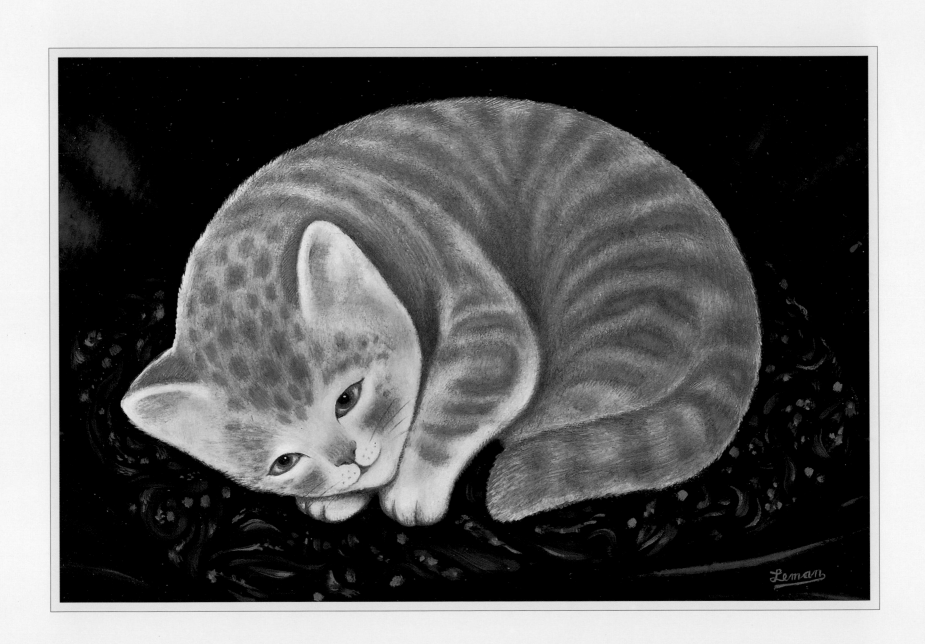

Learning and Exploring

The tail, of course, must come forward until it reaches the front paws. Only an inexperienced kitten would let it dangle.

Lloyd Alexander

SANDY
Martin Leman
.

*W*here are you going?

Why can't I come too?

I'm a kitten, an explorer of all places new.

I have to find out

About all kinds of things,

Such as (for example) why *do* birds have wings?

Please take me with you.

You know it's my plan

To learn all my lessons as fast as I can.

But they've left me behind.

How'm I going to learn?

Well, maybe the next time it will be my turn.

MAGGIE MILES
"Left Behind"

WHERE'D IT GO?
Jill Van Hoorn
. .

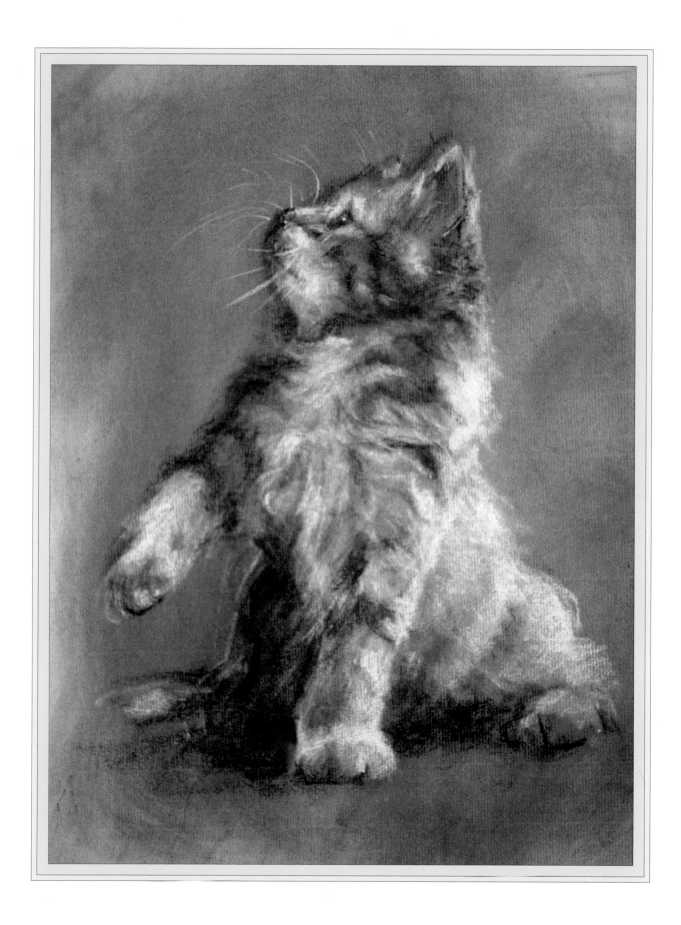

Dame Wiggins of Lee was a worthy soul

As e're threaded a needle, or washed in a bowl;

She held mice and rats in such antipathy,

That seven fine cats kept Dame Wiggins of Lee.

The rats and the mice scared by this fierce-whiskered crew,

The seven poor cats soon had nothing to do;

So, as anyone idle she ne're wished to see,

She sent them to school, did Dame Wiggins of Lee.

But soon she grew tired of living alone,

So she sent for her cats from school to come home:

Each rowing a wherry, returning you see –

The frolic made merry Dame Wiggins of Lee.

ANONYMOUS
"Dame Wiggins of Lee and her Seven Cats"

KITTENS WALKING UPRIGHT
(Artist unknown)

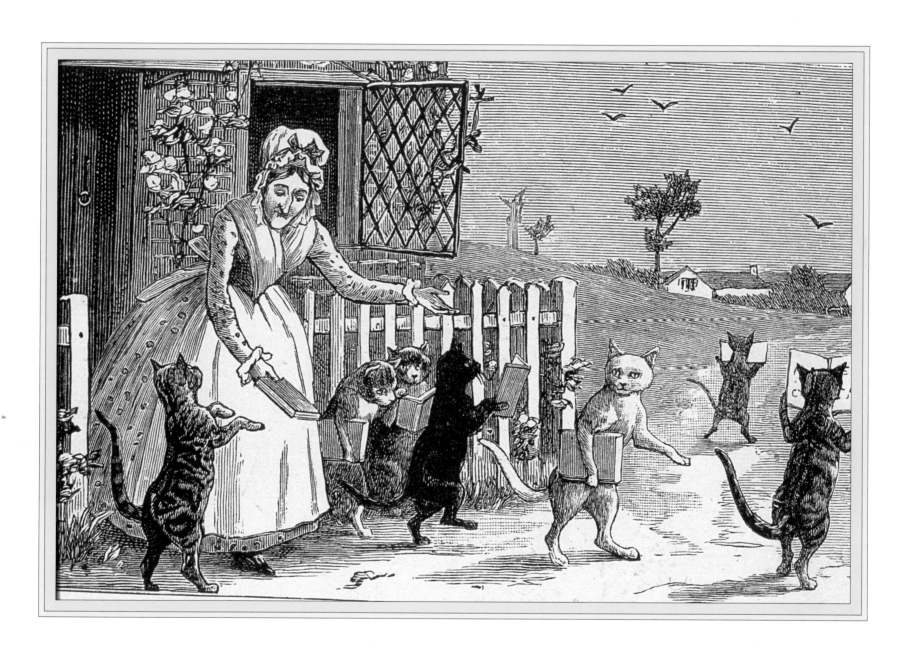

 small kitten, just learning to mouse, will toss up a ball of wool or a bit of fur and make an imaginary mouse with it.

GERTRUDE JEKYLL

FULL OF FUN
Stephen Paul Plant
. .

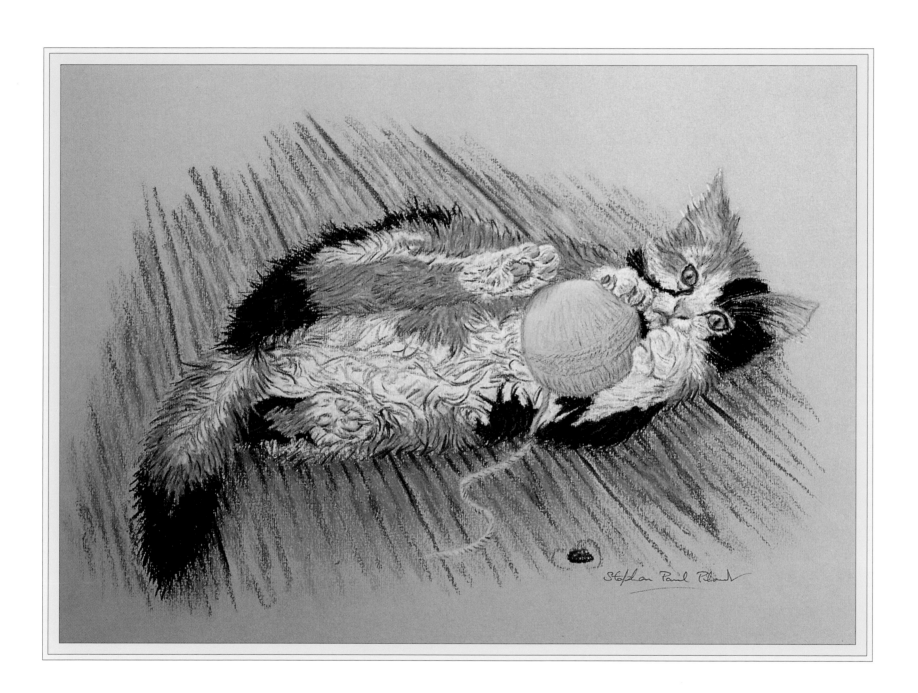

Stephen Paul Plant

A kitten is the most irresistible comedian in the world. Its wide-open eyes gleam with wonder and mirth. It darts madly at nothing at all, and then, as though suddenly checked in the pursuit, prances sideways on its hind legs with ridiculous agility and zeal.

AGNES REPPLIER

FUN ON WASHDAY
Wendy Stevenson

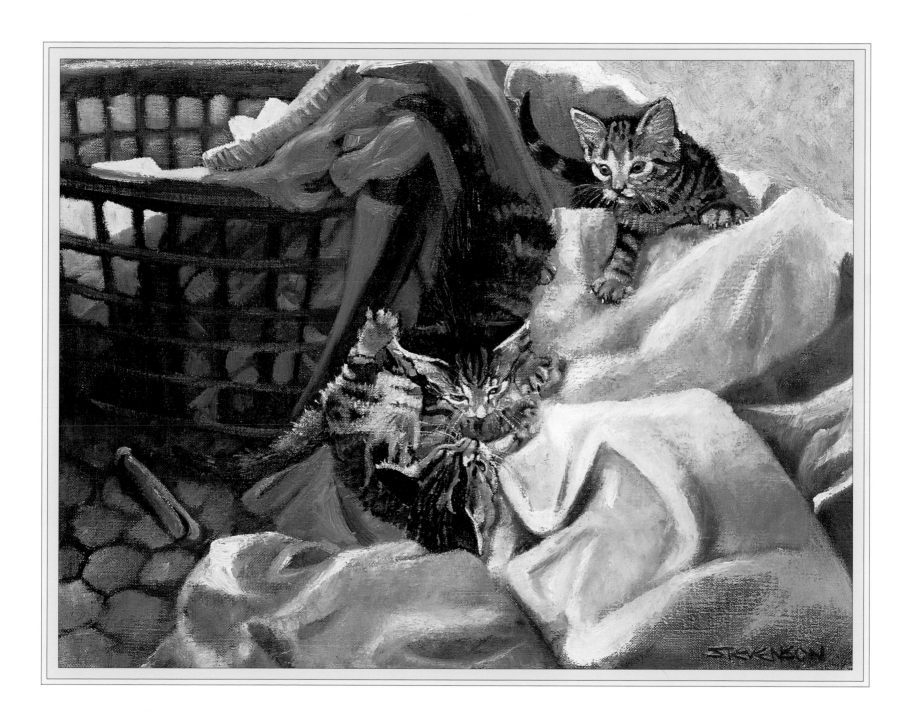

*N*o experiment can be more beautiful than that of setting a kitten for the first time before a looking-glass. The animal appears surprised and pleased with the resemblance, and makes several attempts at touching its new acquaintance; and, at length, finding its efforts fruitless, it looks behind the glass, and appears highly surprised at the absence of the figure.

REV. W. BINGLEY

CAT AND MIRROR
Gillian Carolan

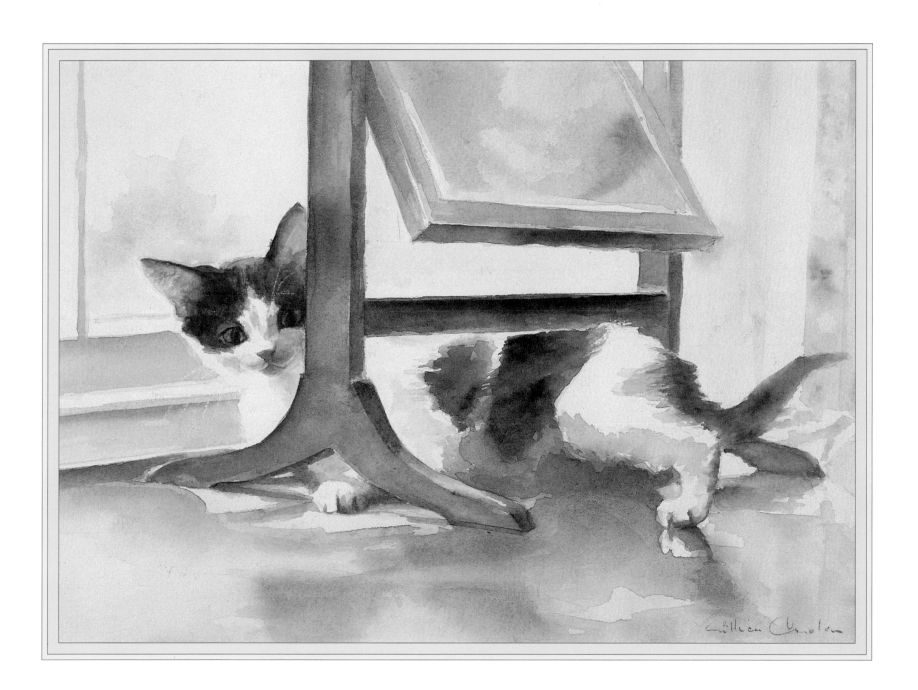

I can do it.
No you can't
Let me show you.
No you shan't.

You pick up the other brush.
Take it gently, do not rush.

I've watched and I know how it's done.
Put brush to paint – oh this is fun!
Just drag the brush along the paper,
There's nothing to this painting caper.
I'll hold the tube down with my paw.
Not too bad. Now try once more.

Stop! What's that I hear?
They're back! It's time to disappear.

LIZ TATE
"The Art Lesson"

DISAGREEMENT UPON A POINT OF ART
Madame Henrietta Ronner

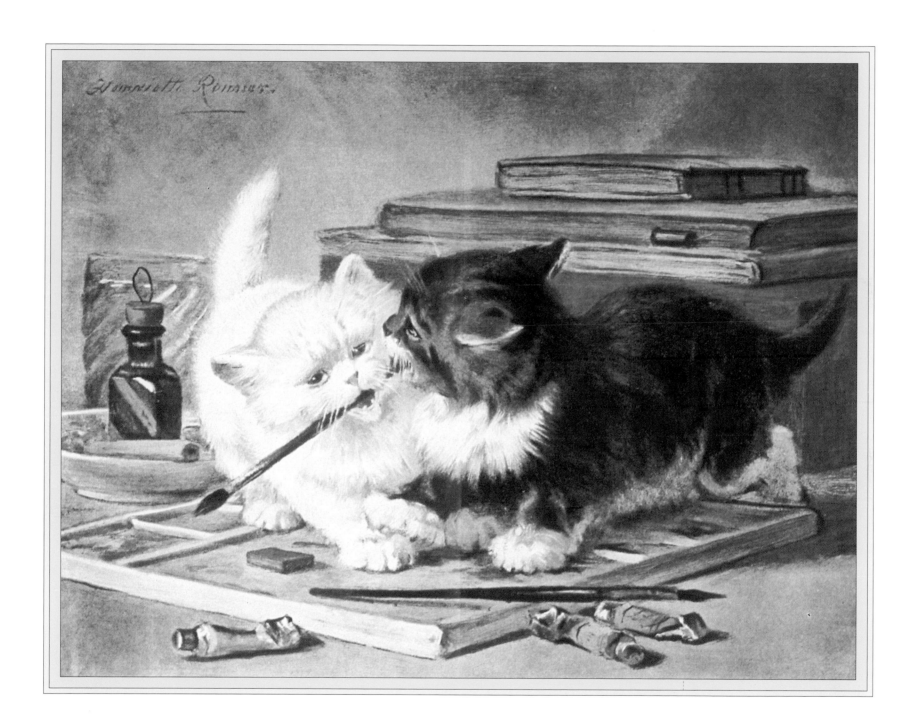

*W*hen People think that Kittens play,
It's really quite the other way.
For when they chase the Ball or Bobbin.
They learn to catch a Mouse or Robin.

The Kitten, deaf to Duty's call,
Who will not chase the bounding ball,
A hungry Cathood will enjoy,
The scorn of Mouse and Bird and Boy.

ANONYMOUS
"Education"

KITTEN HIDING
Clough Bromley

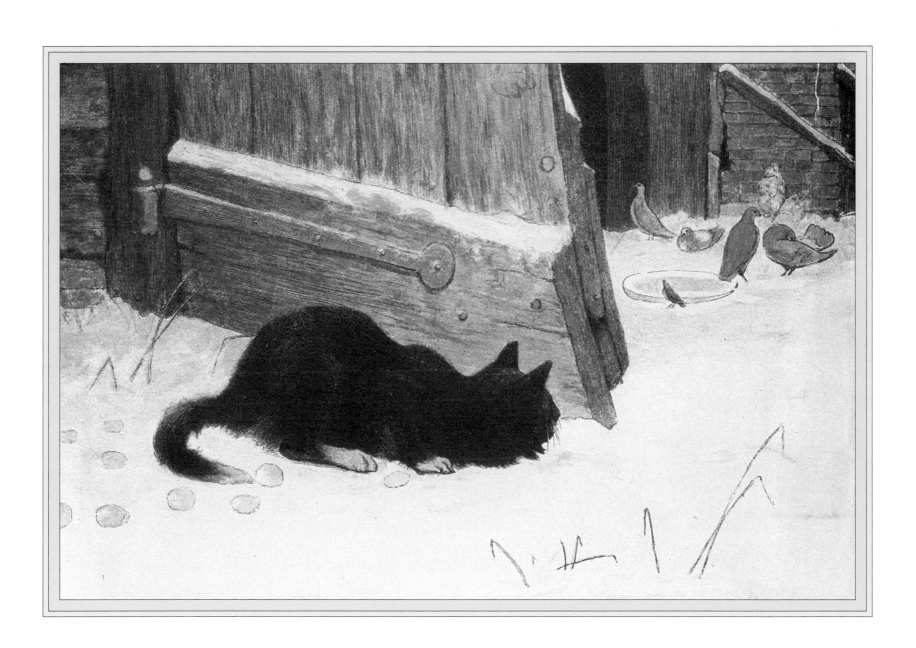

*S*he nestles over the shining rim,

Buries her chin in the creamy sea;

Her tail hangs loose; each drowsy paw

Is doubled under each bending knee.

A long dim ecstasy holds her life;

Her world is an infinite shapeless white,

Till her tongue has curled the last holy drop.

HAROLD MONRO
"Milk For The Cat"

SAUCER OF MILK
A. A. Brunel De Neville
. .

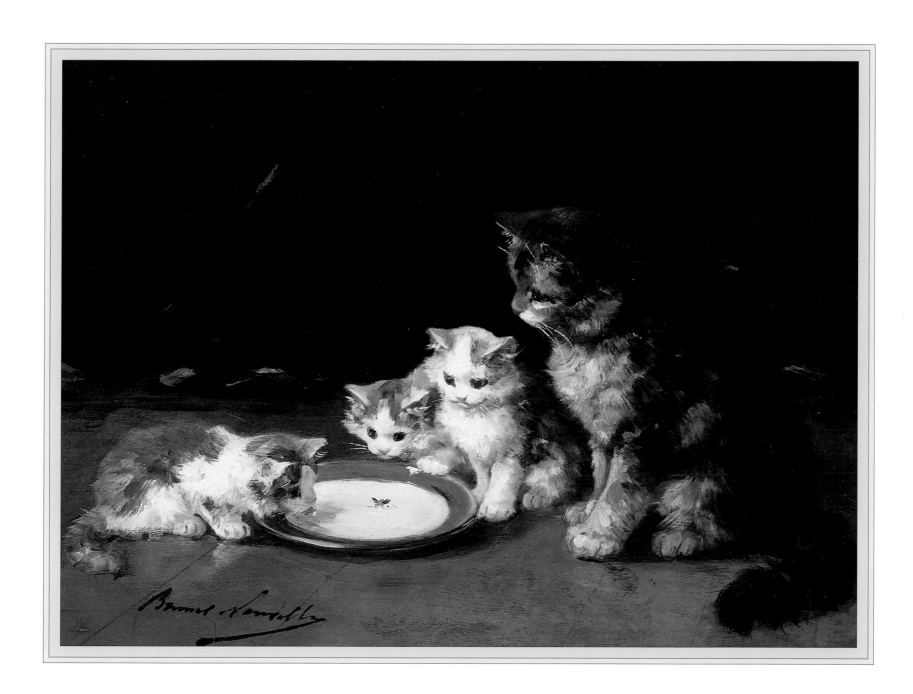

*H*is capacity receiveth as the sea. Not for him the unfelicitous trait of being unable to take too much attention; not for him the sudden bite and claw and furious oscillation of the tail when the strain of being loved gets too great.

From THE CHRISTIAN SCIENCE MONITOR

MOTHER CAT
Karin Van Heerden

The Gentle Milk Jug blue and white
I love with all my soul,
She pours herself with all her might.
To fill my breakfast bowl.

All day she sits upon the shelf,
She does not jump or climb –
She only waits to pour herself
When 'tis my supper-time.

And when the Jug is empty quite,
I shall not mew in vain,
The Friendly Cow, all red and white,
Will fill her up again.

ANONYMOUS
"The Milk Jug"

WEDGWOOD
Martin Leman
. .

I am a talking parrot

These kittens share my house.

I play a little game with them

And imitate a mouse.

I am a talking parrot

And my skills range far and wide.

I can sound just like the telephone,

Or like the doorbell's ring,

I can imitate the baby,

Or the master trying to sing.

I call out like the mother

Of these beribboned three

And they straight away come running

– They don't realize it's me.

But when I try to talk to them

They only mew and purr –

I think there's very little brain

Beneath their silky fur.

ROBERT LOCKHART
"The Talking Parrot"

CATS AND A PARROT
H. Blain

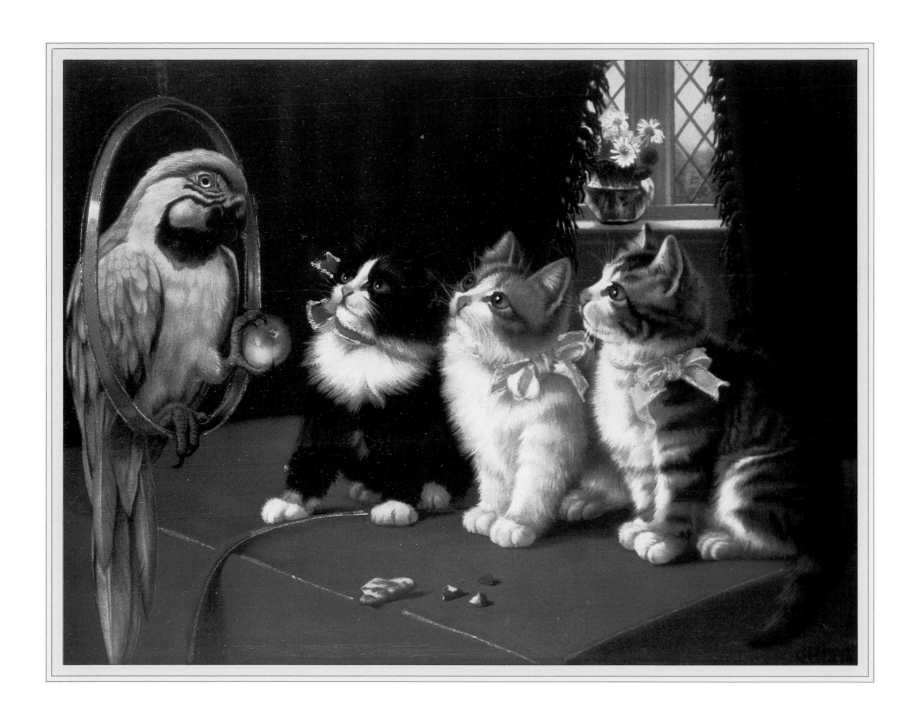

*L*ittle kittens by the sea

Please come home to me for tea,

I know you like to chase the waves

And pretend you're tigers exploring caves,

But you are only kittens small

And a great big whale might eat you all.

HONOR HEAD
"Come Home to Me"

ALL AT SEA
Louis Wain
.

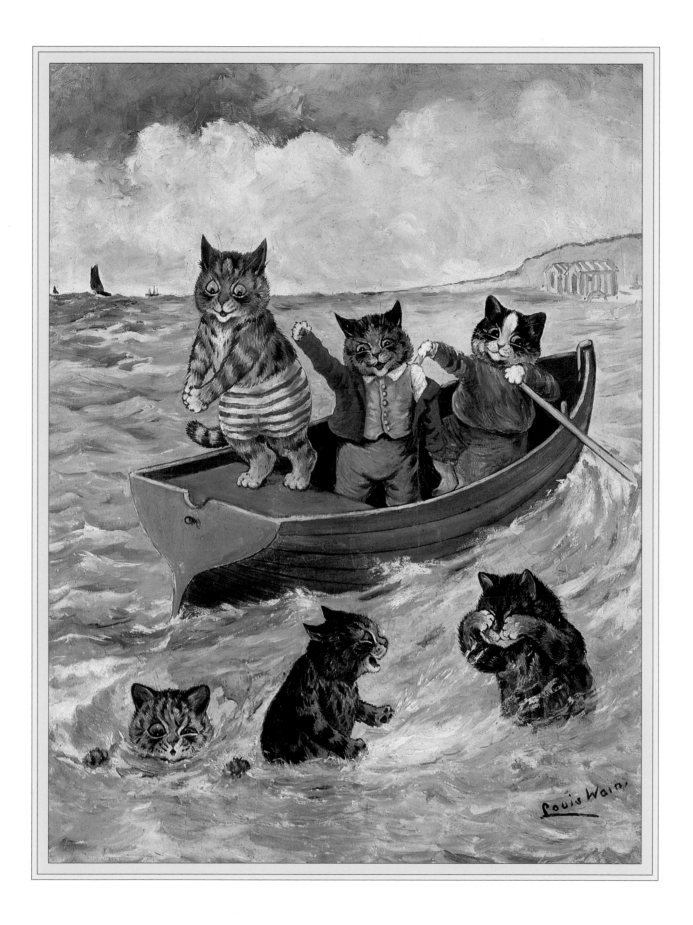

*P*ussy was a goddess in old Egypt and she has never forgotten it. Old incense perfumes her soft fur. A goddess in exile, she exacts honour as any queen who has lost a realm but will have her court and its courtiers.

OSWALD BARRON

THE MUSEUM CAT
Francis Broomfield

58

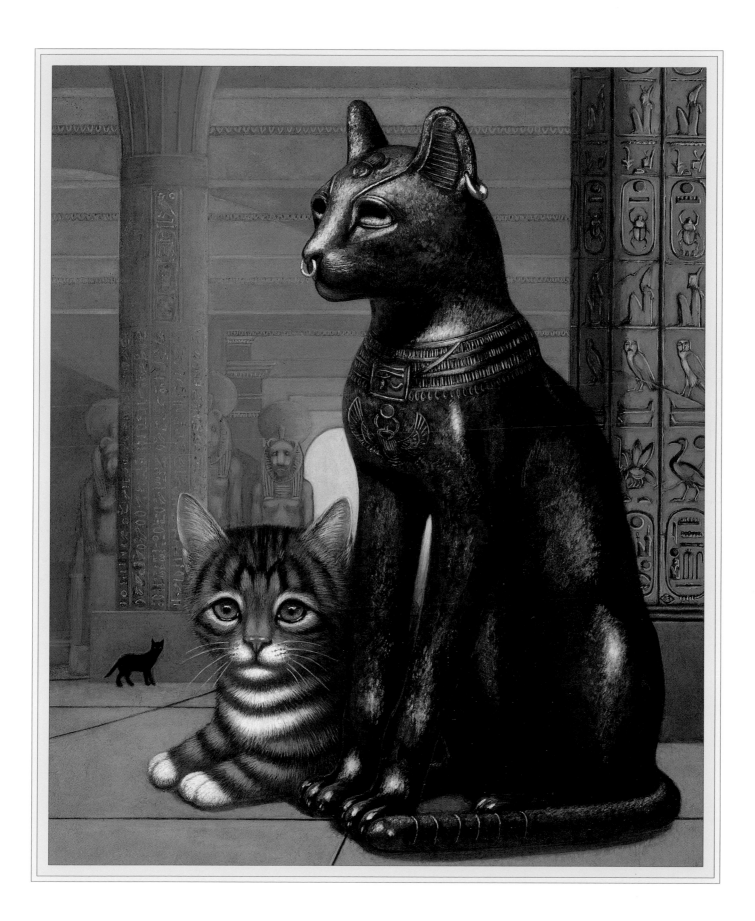

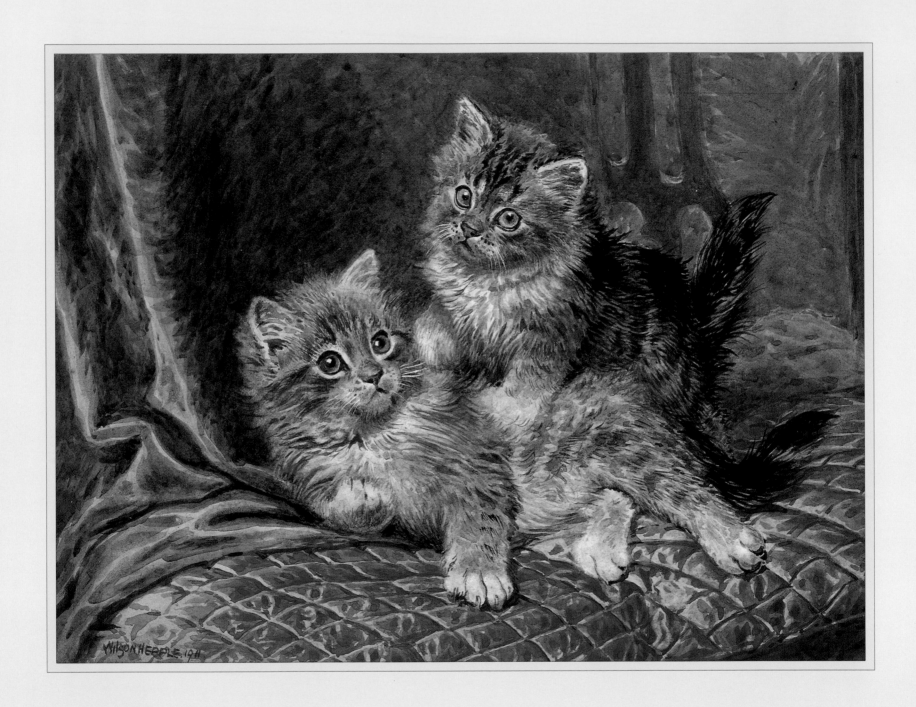

Looking for Mischief

"Oh, you wicked, wicked little thing!" cried Alice,
catching up the kitten and giving it a little kiss to make
it understand that it was in disgrace."
Lewis Carroll

THE MISCHIEVOUS TWINS
Wilson Hepple
.................................

*K*ittens large and Kittens small,
Prowling on the backyard wall,
Though your fur be rough and few,
I should like to play with you.

ANONYMOUS
From "Foreign Kittens"

OUT TO PLAY
Oliver Herford

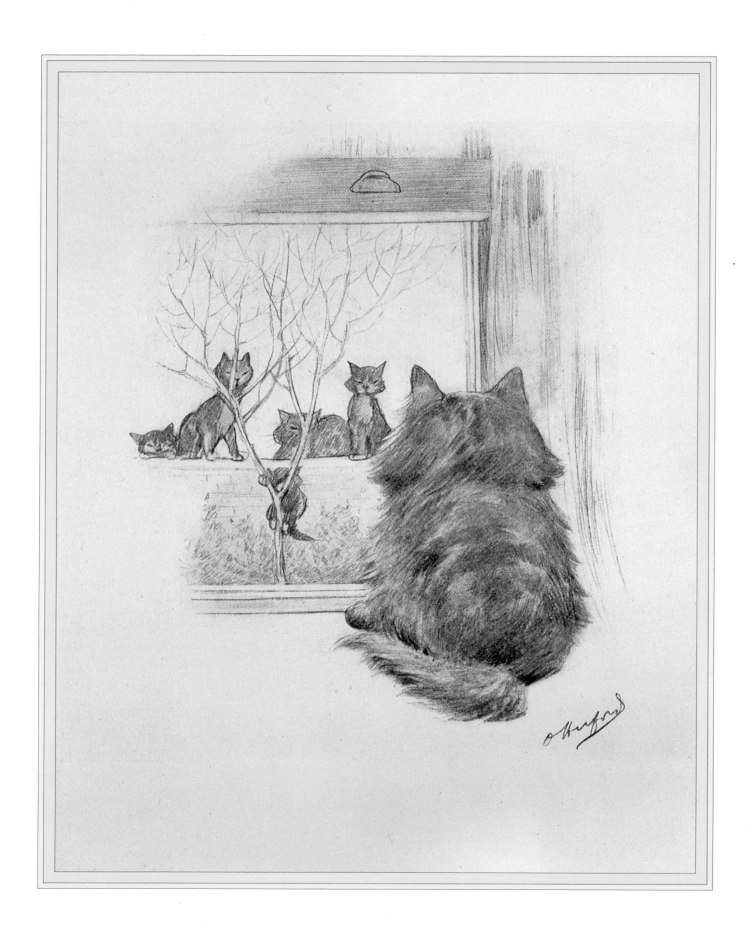

Our Kitten, the one we call Louie,

Will never eat liver so chewy,

Nor the milk, nor the fish

That we put on the dish,

He will only dine on chop suey.

ANONYMOUS
"Our Kitten"

MR MISTOFFELEES
Cheryl Osborne

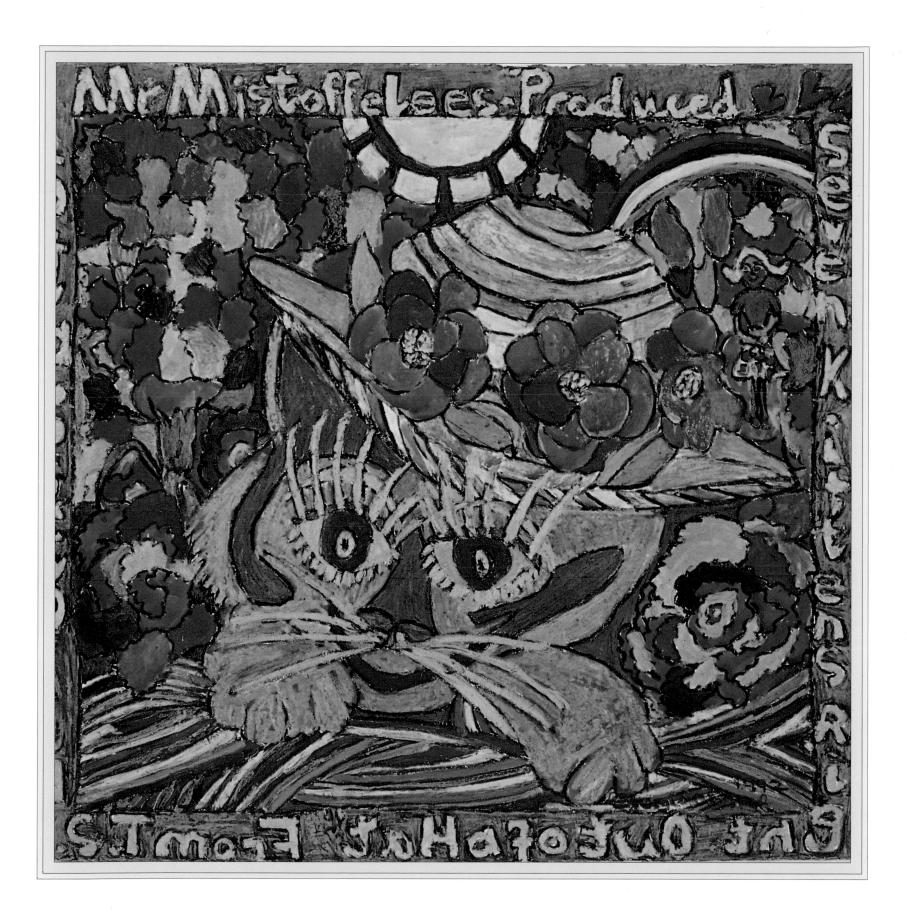

Tom Quartz is certainly the cunningest kitten I have ever seen. He is always playing pranks on Jack and I get very nervous lest Jack should grow too irritated. The other evening they were both in the library, Jack sleeping by the fire . . . Suddenly he (Tom Quartz) spied Jack and galloped up to him. Jack . . . jumped out of the way and got upon the sofa and around the table, and Tom Quartz instantly jumped upon him again. Jack shifted to the other sofa, where Tom Quartz again went after him. Then Jack made a start for the door, while Tom made a rapid turn under the sofa and around the table and just as Jack reached the door leaped upon his hind quarters. Jack bounded forward and away and the two went tandem out of the room – Jack not co-operating at all; and about five minutes afterwards Tom Quartz stalked solemnly back.

THEODORE ROOSEVELT
From a letter to his daughter dated 6th January 1903

NOSE TO NOSE
Wendy Stevenson
. .

Then I, the dangerous Kitten, prowl
And in the Shadows softly growl,
And roam about the farthest floor
Where Kitten never trod before.

And, crouching in the jungle damp,
I watch the Human Hunters' camp
Ready to spring with fearful roar
As soon as I shall hear them snore.

ANONYMOUS
From "In Darkest Africa"

From CATCH THAT CAT
Monika Beisner

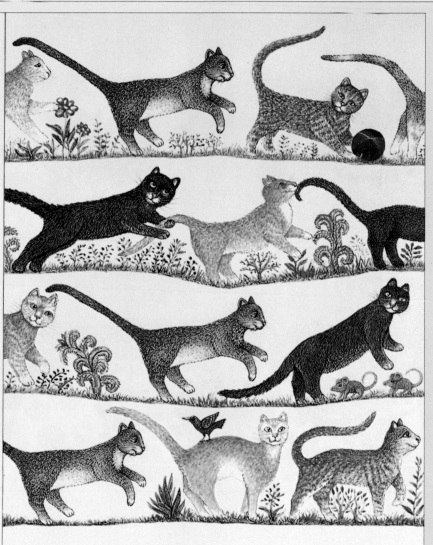

My brother's a tabby
and I'm black and white,
But though he looks different
he's my brother all right.
He's quite a lot bigger and he thinks that he's fitter –
He calls me "the runt", the last of the litter.
But really I'm fine, though I quite like the way
He makes it his job to protect me all day.
He never lets anyone bully me, ever,
And always makes sure I get my share of dinner.
All day we chase, and we tumble and fight,
Then we curl up together all cosy at night.

TOM HOWARD
"The Runt"

KITTENS ON STAIRS
Gillian Carolan

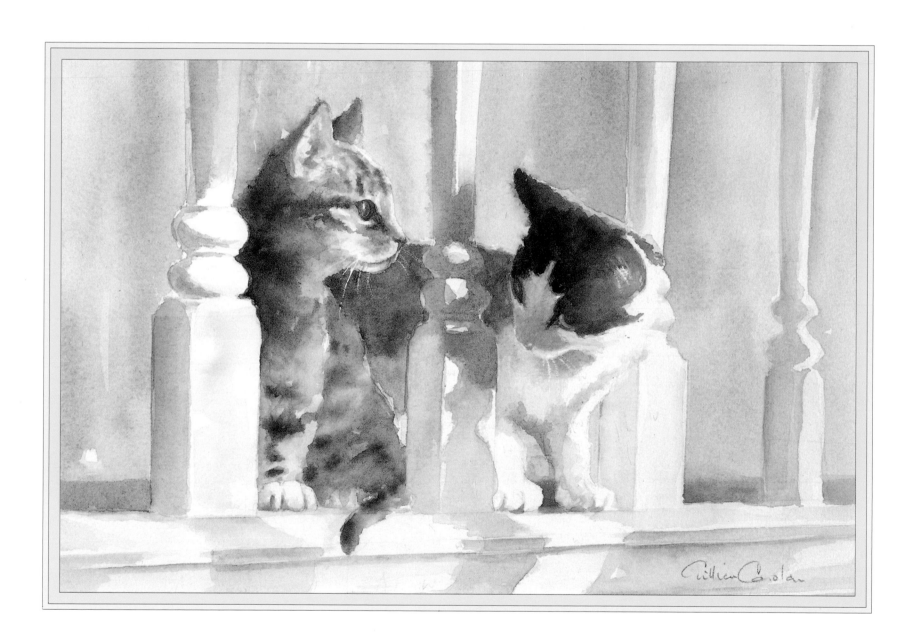

There's a funny little kitten that tries to look like me,

But though I'm round and fluffy, he's as flat as

flat can be;

And when I try to mew to him he never makes a sound,

And when I jump into the air he never leaves the ground.

He has a way of growing, I don't understand at all.

Sometimes he's very little and sometimes he's very tall.

And once when in the garden when the sun came up at dawn.

He grew so big I think he stretched half-way across the lawn.

ANONYMOUS
"The Shadow Kitten"

FLUFFY
Esther Walton

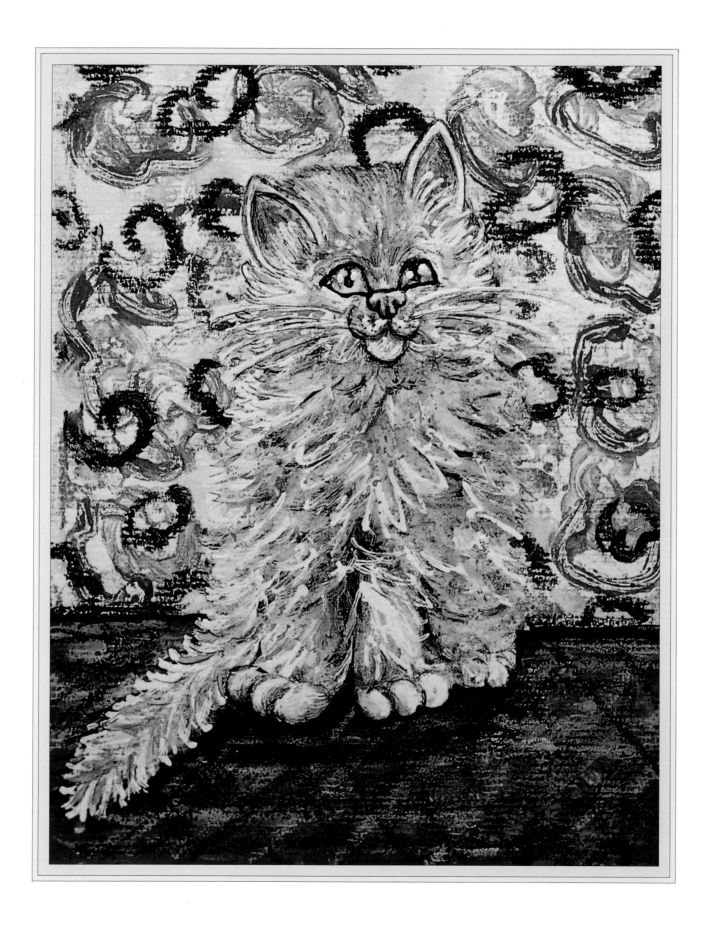

*A*s the kittens grew older they became more and more frolicsome, swarming up the curtains, playing about the writing table and scampering behind bookshelves. But they were never complained of and lived happily in the study until the time came for finding them other homes. One of these kittens was kept, who, as he was quite deaf, was unnamed, and became known by the servants as "the master's cat" because of his devotion to my father.

MAMIE DICKENS, DAUGHTER OF CHARLES DICKENS

A BOX OF TREASURE
Jules Le Roy

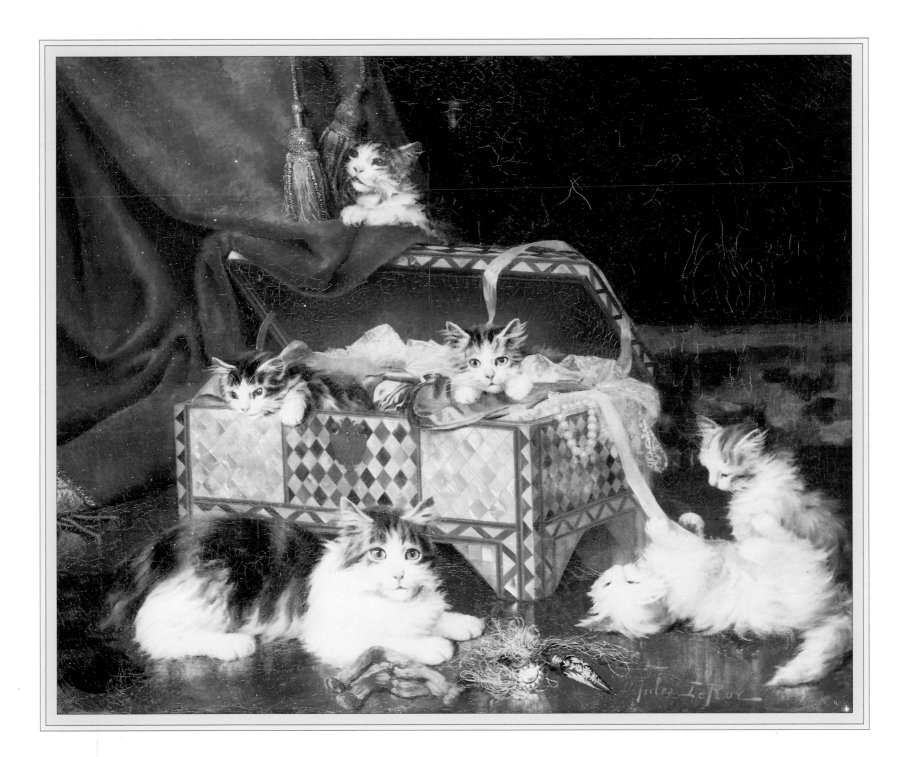

The Kitten mews outside the Door,

The Cat-bird in the Tree,

The Sea-mew mews upon the Shore,

The Catfish in the Sea.

ANONYMOUS
From "A Kitten's Fancy"

THE FISH BOWL
Trisha Rafferty
. .

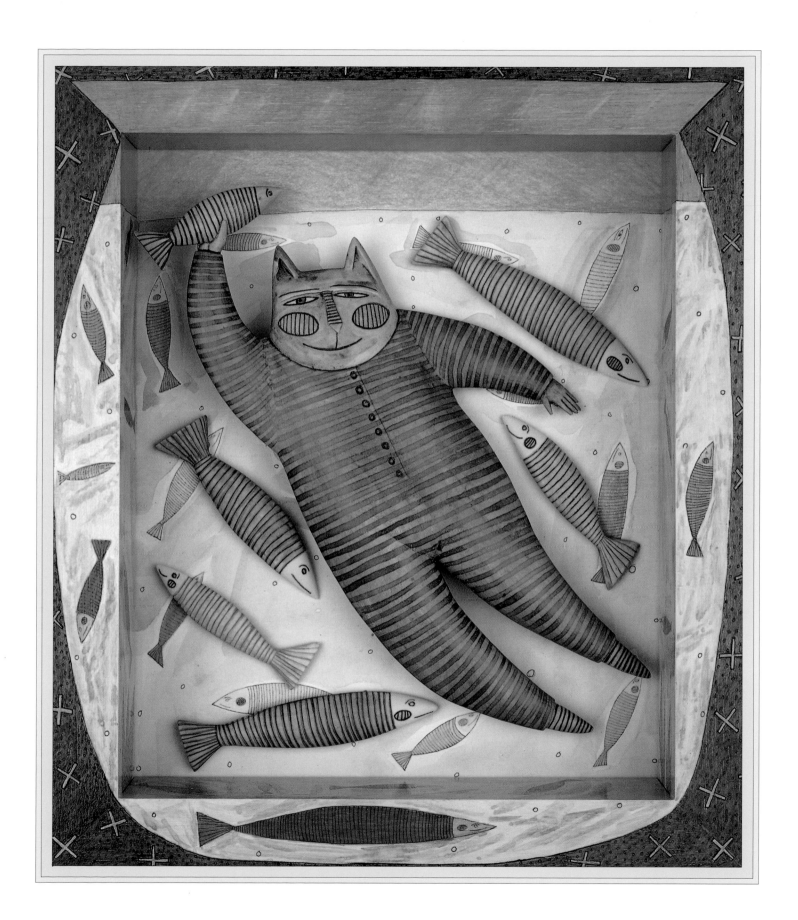

On my return Charlotte met me with "Oh! Whatever *do* you think the kitten has gone and done? . . . pulled down the cage and the weight, and broke the chain and upset the little table and broke everything on it! . . . I suppose the dreadful crash she made frightened *herself*; for I met *her* running downstairs as I ran up – tho' the cage was on the floor, and the door open . . .!"

JANE CARLYLE
From a letter written in 1860

IN POSSESSION
From a painting by L. Lambert
. .

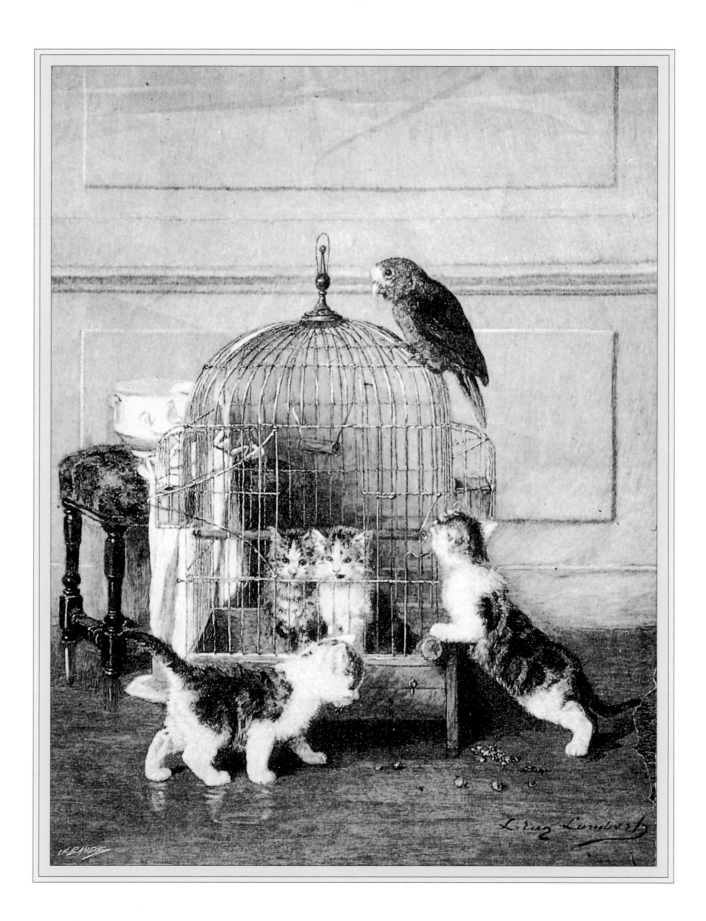

The poet who wrote so prettily of him that his little life was rounded with a sleep understated his felicity; it was rounded with a good many. His conscience never seemed to interfere with his slumbers.

CHARLES DUDLEY WARNER
From "My Summer in a Garden"

SLEEPY HEAD
Jill Van Hoorn

. .

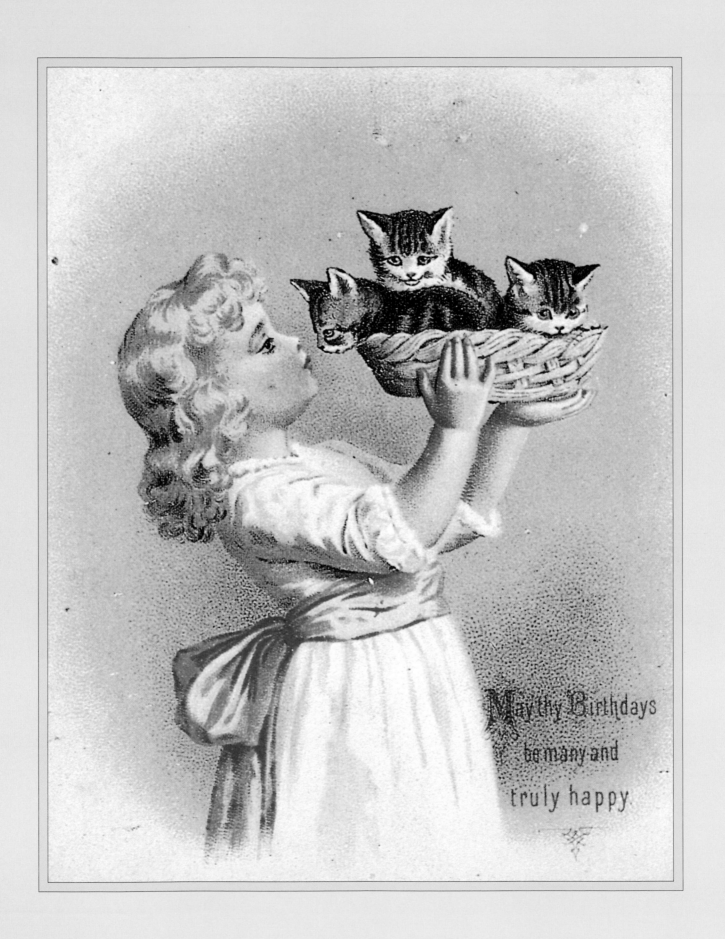

Making Friends

Our perfect companions never have
fewer than four feet.

Colette

LITTLE GIRL HOLDING THREE KITTENS IN A BASKET
(Artist unknown)

It's a very inconvenient habit of kittens
(Alice had once made the remark) that,
whatever you say to them, they always purr.

LEWIS CARROLL
From "Alice Through The Looking Glass"

PEBBLES
Martin Leman
.

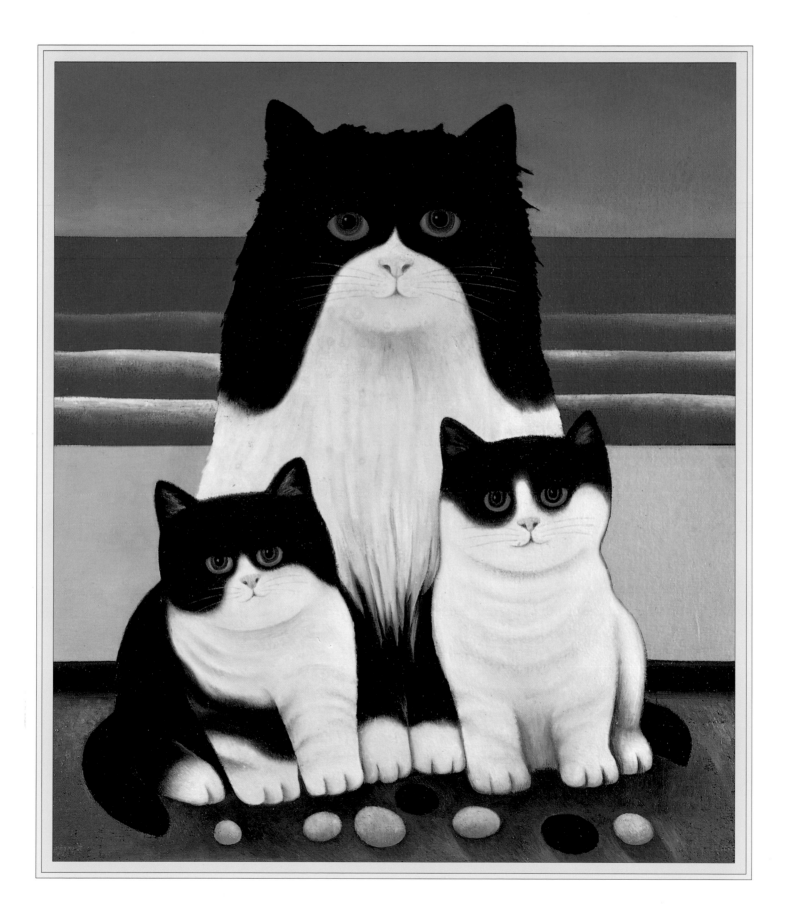

*D*ear Father, hear and bless
Thy beasts and singing birds,
And guard with tenderness
Small things that have no words.

FROM HYMNS AND PRAYERS FOR CHILDREN

SUSPENSE
(Artist unknown)

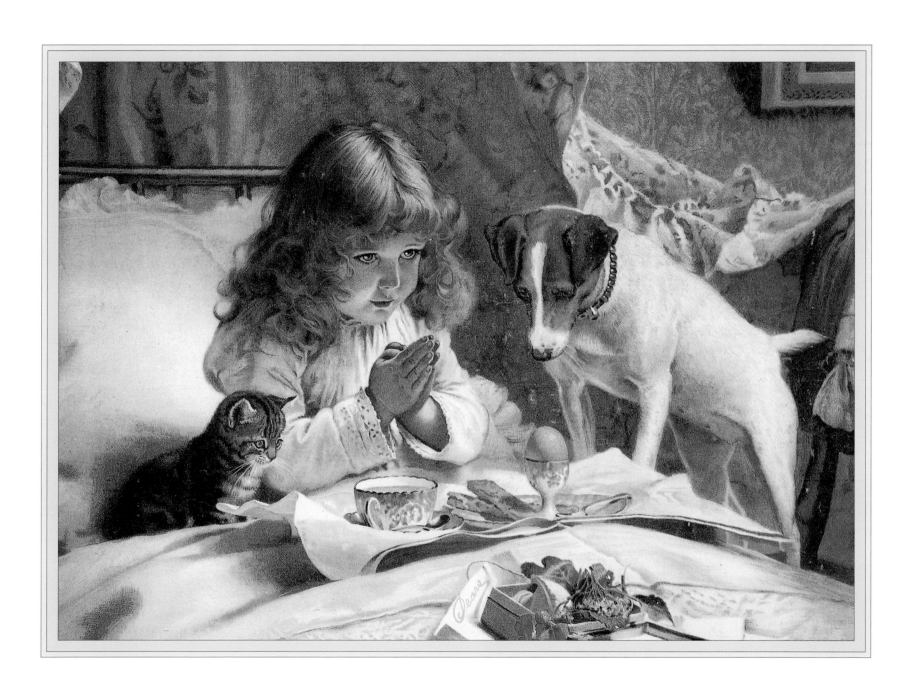

The dog came in and woke us up,
We chased him round and round.
He knocked the table over
And everything fell down.

Down on the floor came cotton reels
And rolled-up hanks of thread,
A thimble and all kinds of things
That nearly hit my head.

But best of all a little box
That spilled out tiny balls
Which we can bat around the room
Until the pleasure palls.

JANE PARSONS
"Cunning Kittens"

A CATCHY CATASTROPHE
Times Literary Supplement 1890

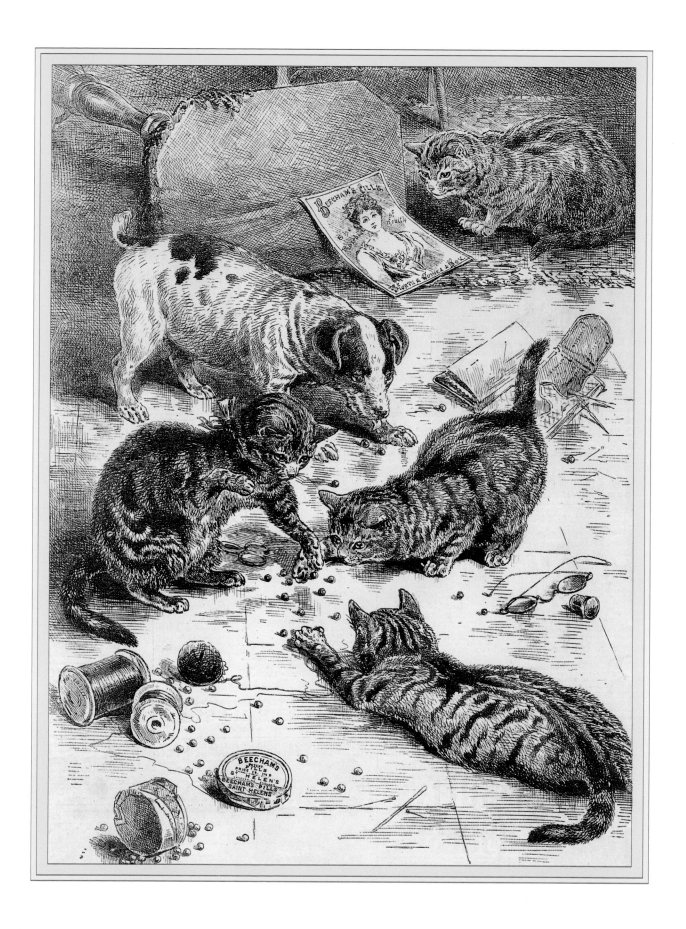

*W*atching a ball on the end of a string,

Watching it swing back and to,

Oh, I do think it is the pleasantest thing

Ever a Kitten can do.

ANONYMOUS

THE GAME
Charles Petit
· · · · · · · · · · · · · · · · · · · ·

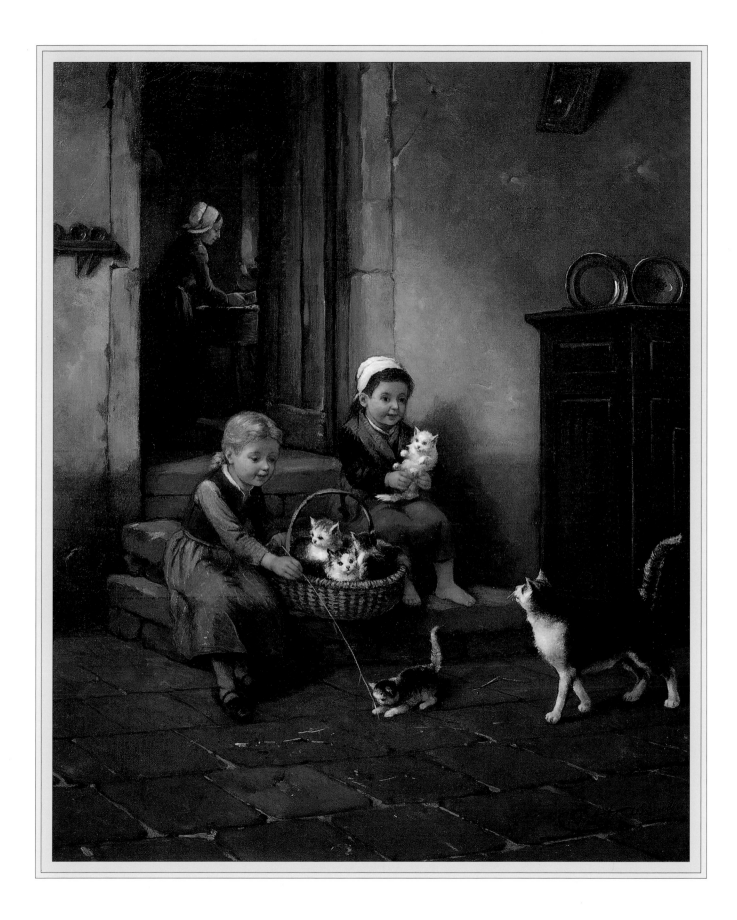

Ten little mice sat in a barn to spin,

Puss came by, and popped her head in:

What are you at, my jolly ten?

We're making coats for gentlemen.

Shall I come in and cut your threads?

No, Miss Puss, you'd bite off our heads.

ANONYMOUS
From "Ten Little Mice"

KITTEN AND MOUSE
Stephen Paul Plant

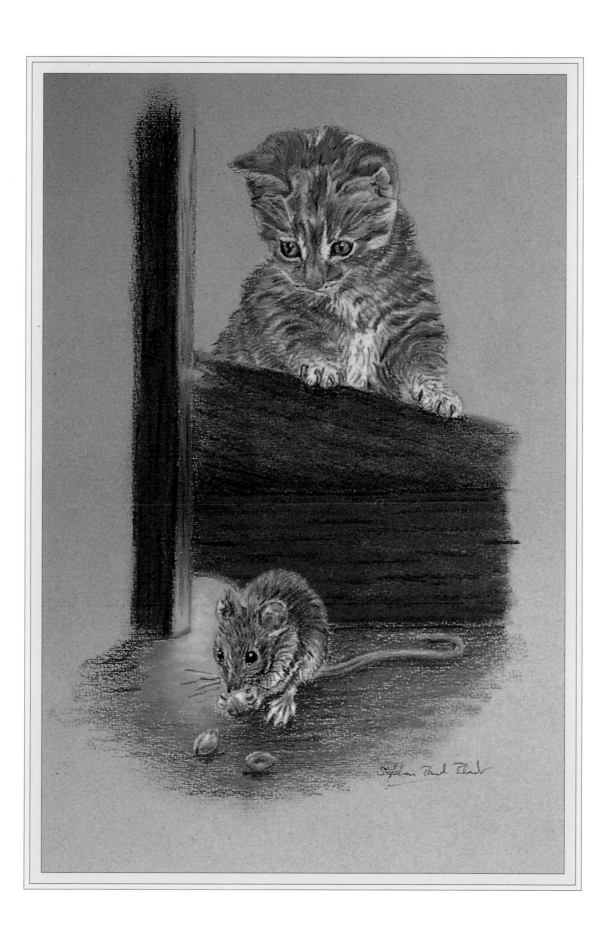

*H*unting mice is his delight,

Hunting words I sit all night.

'Gainst the wall he sets his eye,

Full and fierce and sharp and sly,

'Gainst the wall of knowledge I

All my little wisdom try.

Irish Poem, quoted by Helen Waddell in a translation by Robin Flower

READING ALOUD
V. Marais-Milton

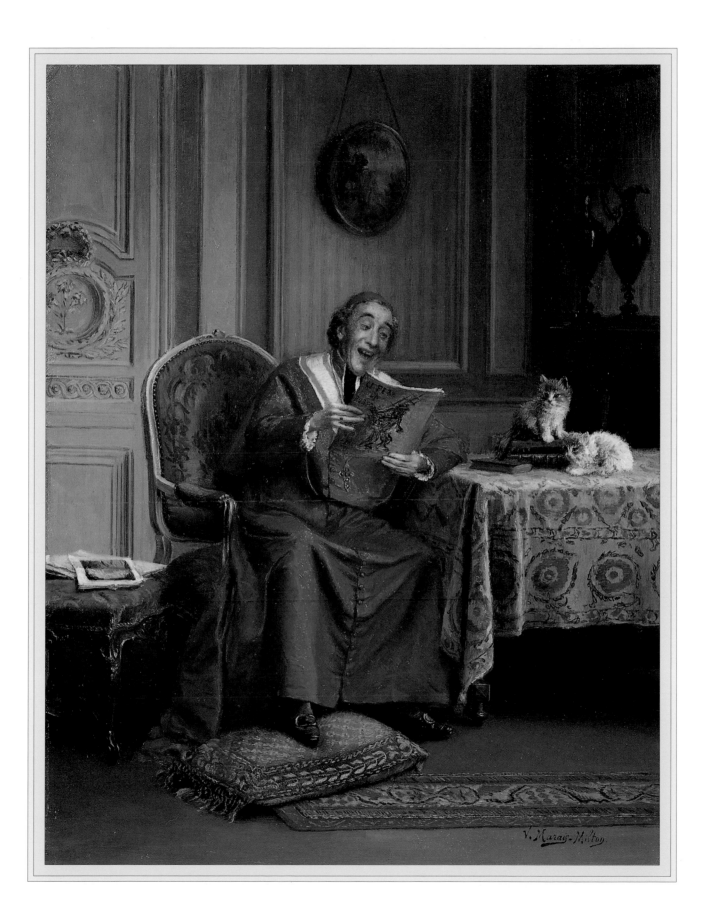

*S*ome people say life is like a bowl of cherries.
I think it is more like a basketful of kittens
– delightful, mischievous and totally unpredictable.

JOAN SUTTERBY

A BASKET OF MISCHIEF
Emile Vernon

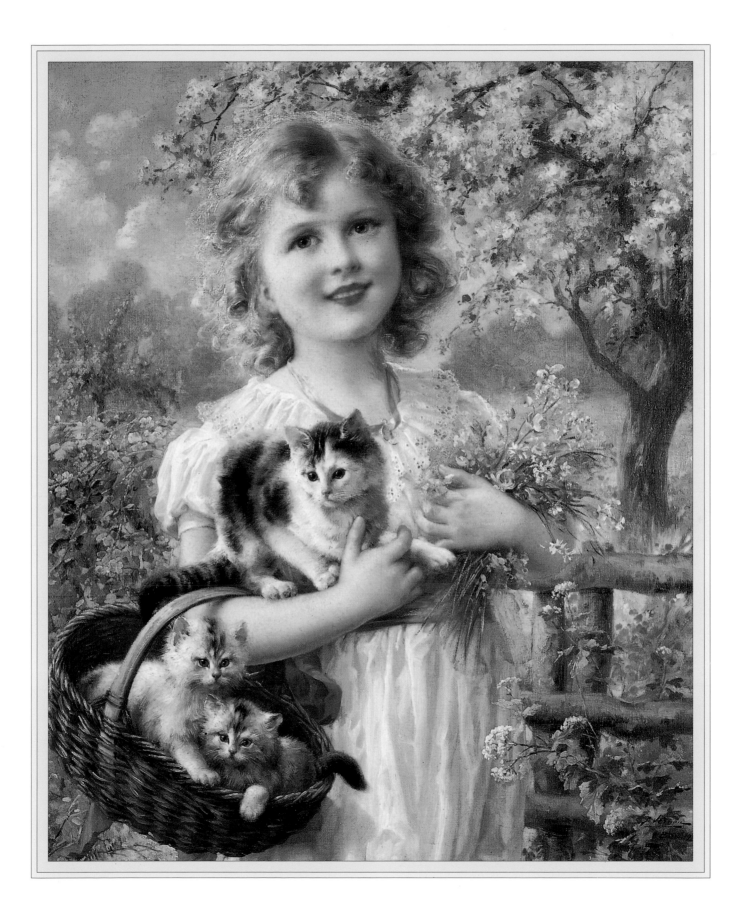

What is a friend?

A single soul dwelling in two bodies.

ARISTOTLE

TWO KITTENS ONE WITH PINK BOW
(Artist unknown)

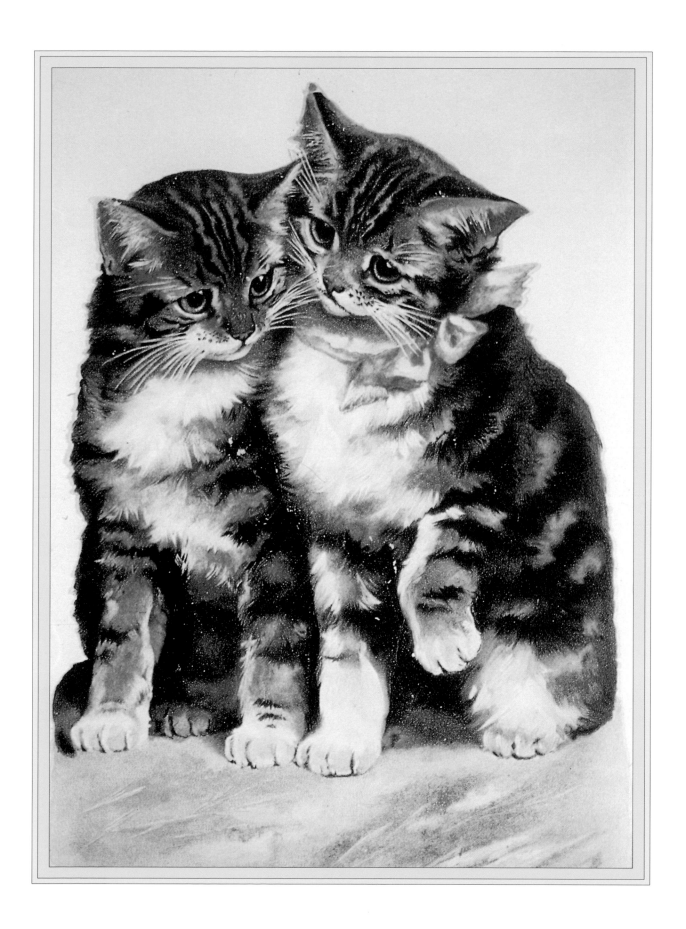

I love little pussy

Her coat is so warm,

And if I don't hurt her

She'll do me no harm.

So I'll not pull her tail

Nor drive her away,

But pussy and I

Very gently will play.

NURSERY RHYME

LITTLE BOY HOLDING KITTEN AND FISHBOWL
(Artist unknown)

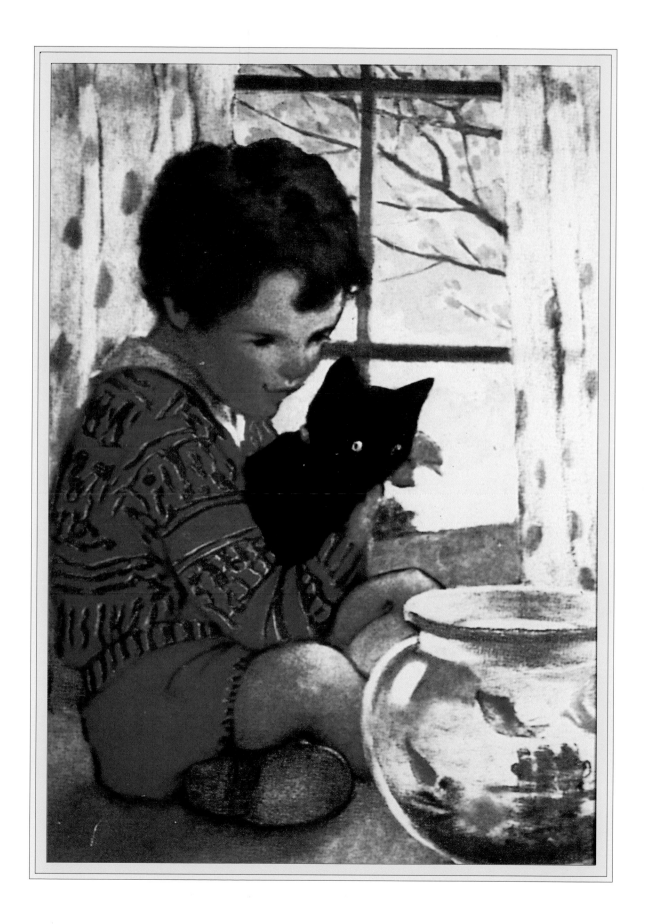

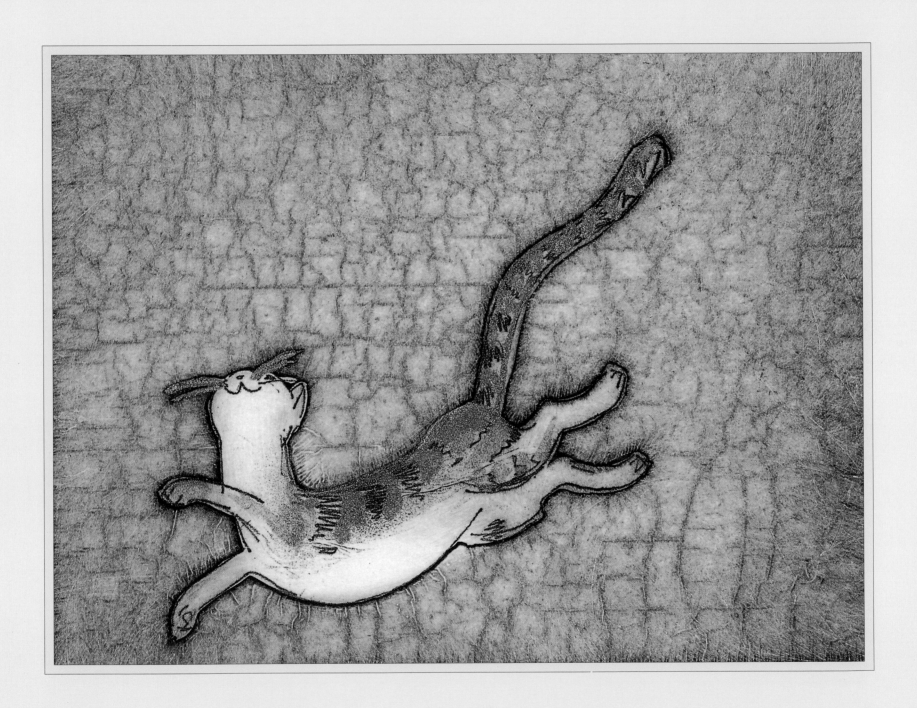

Days Out and Celebrations

To a kitten, every day is a holiday.

Janet Robinson

GOLDEN WHISKERS
Julian Williams
. .

Twas the night before Christmas,

when all through the house,

Not a creature was stirring, not even a mouse,

The stockings were hung by the chimney with care,

In hopes that St Nicholas soon would be there.

PROFESSOR CLEMENT C. MOORE
From "A Visit from St Nicholas"

PARTY GAMES
Wendy Stevenson

. .

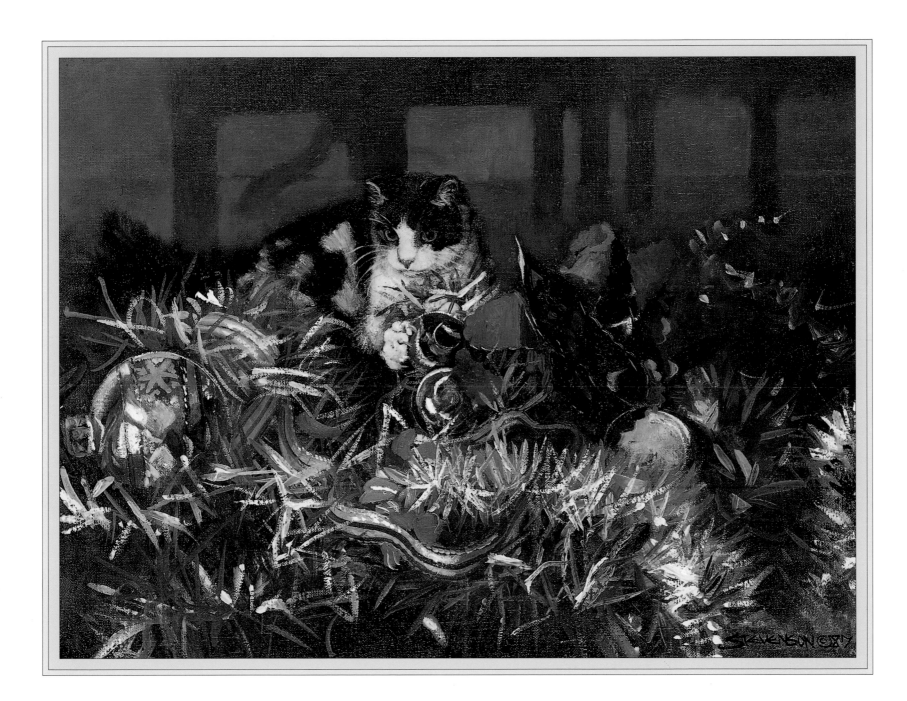

Pussy cat, pussy cat where have you been?
I've been to London to visit the Queen.
Pussy cat, pussy cat what did you there?
I frightened a little mouse under her chair.

TRADITIONAL SONG

THE CHAUFFEUR
Louis Wain

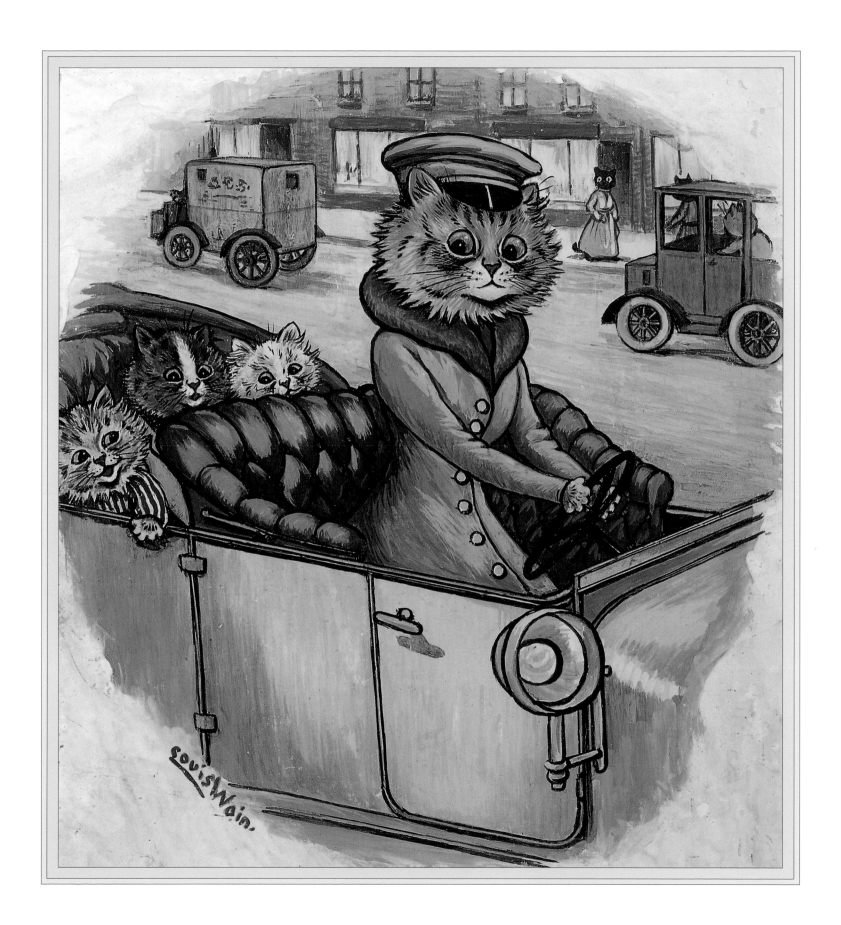

I found the perfect Christmas gift for Marie – the prettiest, fluffiest little kitten with enormous eyes and, yes, a slightly lop-sided grin. But how to wrap this perfect present? Holes in a box? Too cruel, and besides, this didn't look like a kitten that would take to spending the night under a Xmas tree in a box, no matter how comfortable I tried to make it. Eventually I decided to dispense with gift boxes, wrapping paper and fancy bows. On Xmas Eve while Marie slept I placed the kitten on the bed. It slowly and delicately entwined itself around Marie's shoulder and she woke on Christmas morning to the softness of kitten down against her cheek and gentle purring in her ear.

HONOR HEAD
From "The Christmas Cat"

FIRST XMAS
Martin Leman
.

*P*ussy-cat Mew jumped over a coal,

And in her best petticoat burnt a great hole.

Pussy-cat Mew shall have no more milk

Till she has mended her gown of silk.

RHYMES FOR THE NURSERY, 1839
"Pussy-cat Mew"

MILLINER CAT
Louis Wain

That is how in Foreign Places
Fluffy Cubs with Kitten faces,
When the mango waves sedately
Grow to Lions large and stately.

ANONYMOUS
"Foreign Places"

BIRTHDAY CAKE
Karin Van Heerden

112

*H*ey, my kitten, my kitten,
　　And hey my kitten, my deary,
　　Such a sweet pet as this
There is not far nor neary.
Here we go up, up, up,
Here we go down, down, downy;
Here we go backwards and forwards,
And here we go round, round, roundy.

NURSERY RHYME
"Dandling"

PUSSYKINS: KITTENS IN A FAIRGROUND SWING
(Artist unknown)

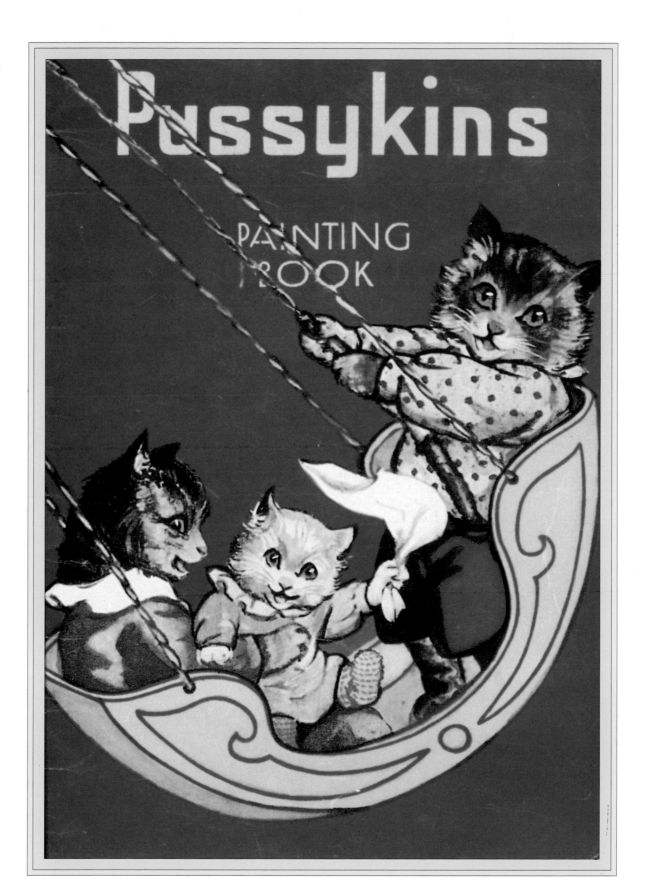

The Owl and the Pussy-cat went to sea

In a beautiful pea-green boat,

They took some honey, and plenty of money,

Wrapped up in a five-pound note.

The Owl looked up to the stars above,

And sang to a small guitar,

"O lovely Pussy! O Pussy, my love,

What a beautiful Pussy you are,

You are

You are!

What a beautiful Pussy you are!"

EDWARD LEAR
From "The Owl And The Pussy-cat"

THE OWL AND THE PUSSYCAT
Trisha Rafferty

They say that the test of literary power is whether
a man can write an inscription.
I say, "Can he name a kitten".

SAMUEL BUTLER

From CATCH THAT CAT
Monika Beisner

See the kitten on the wall

Sporting with the leaves that fall . . .

But the kitten how she starts,

Crouches, stretches, paws and darts!

First at one and then its fellow. . . .

WILLIAM WORDSWORTH
From "Kitten and the Falling Leaves"

OUT OF THE BASKET
Edgar Hunt

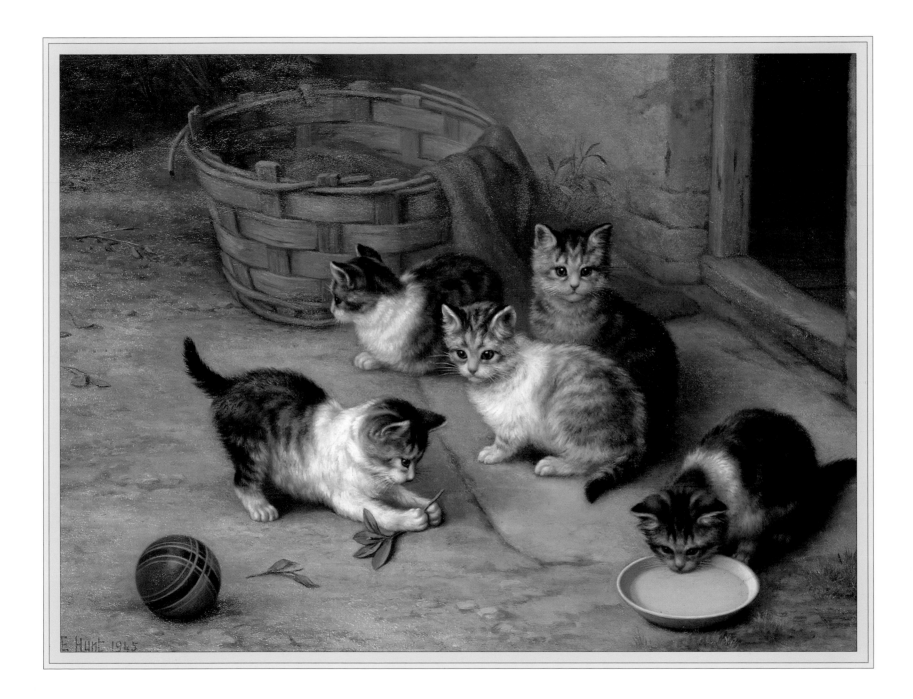

*S*ince our kittens are so clever

At washing themselves

And keeping their coats spick and span,

It's a pity they can't

Be cleverer still

And make use of a small brush and pan.

Now they've rid us of mice

It would be very nice,

When at night they don't have to go hunting,

If they'd just have the will

To learn a new skill

And have all the house clean by morning.

PAUL USBORNE
"Household Duties"

SPRING CLEANING
Louis Wain

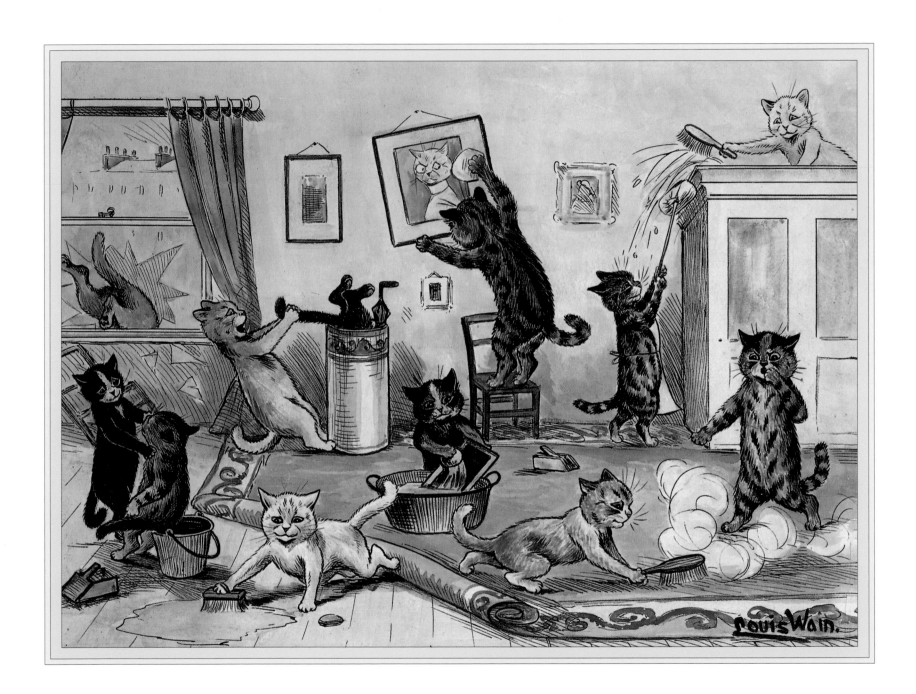

*H*ello! I'm Thomasina, though my friends

all call me Tom.

Now tell me, what is your name, and

where do you come from?

Well, why don't you answer me when I say "Good day"?

Don't you know I'm asking you to come with me and play.

SOPHIE BISSETT
"Playtime"

BELLA AND TED
Wendy Stevenson
. .

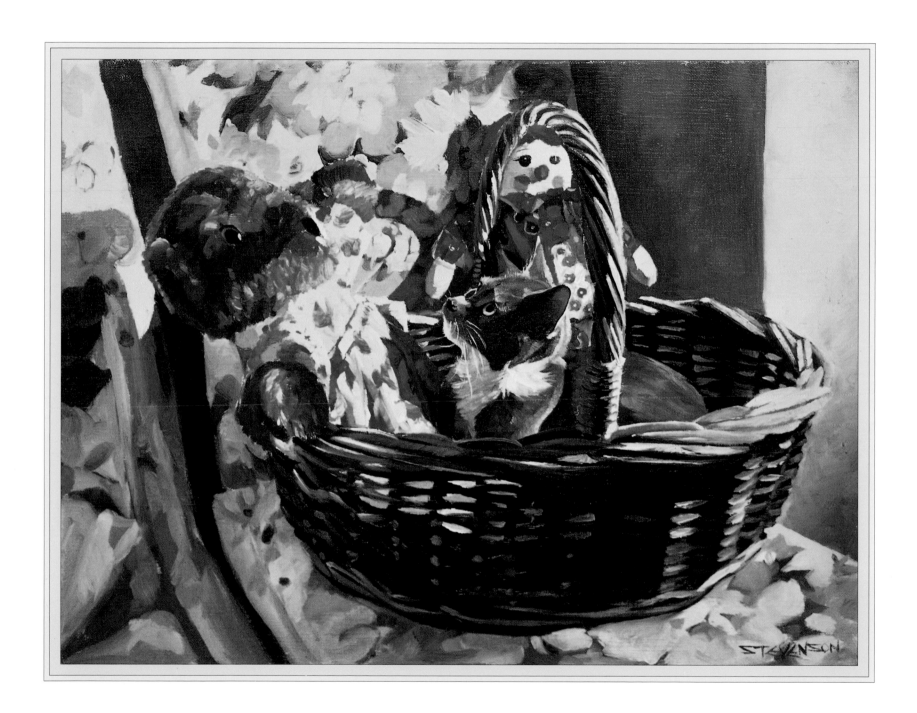

"What a day,

Full of excitement,

So many new things I discovered.

What a day,

I learned so much.

So many things to be remembered.

Before I sleep

I'll do my best . . ."

But already kitty slumbered.

PAT WILLIAMS
"What a Day"

SLEEPYHEAD
Gillian Carolan
.

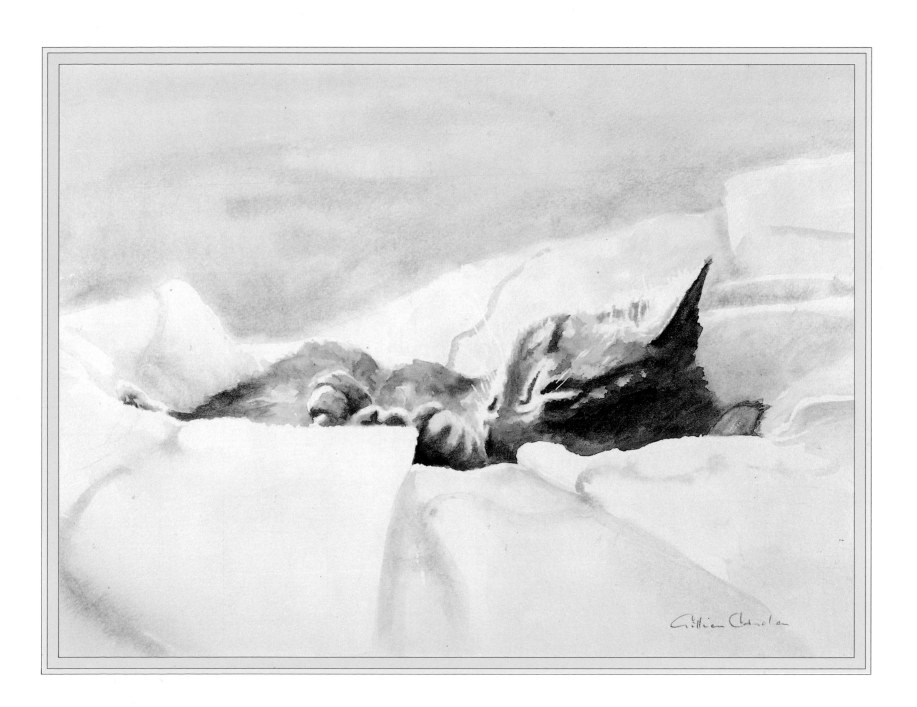

ACKNOWLEDGEMENTS

The publisher would like to thank all the contributing artists whose work has been featured in this publication, and the following galleries, libraries and companies.

page 2, 23, 41, 67, 105, 125	Courtesy of the Cottage Gallery Mansfield Notts.
page 6, 102	Julian Williams, Two Bad Mice Company.
page 15, 17, 37, 45, 47, 115, 79, 83, 87, 99, 101	From collection of the Vintage Magazine Co Picture Library.
page 19	Royal Worcester.
page 21, 57, 107, 111, 123	Courtesy of the Michael Parkin Gallery.
page 25, 51	Karin Designs Ltd.
page 27, 29	Bonhams/The Bridgeman Art Library.
page 31	Edith F. Grey/The Bridgeman Art Library.
page 43, 71, 127	By kind arrangement from Park Lane Publishing.
page 49, 91, 95, 121	John Noot Galleries, Broadway.
page 113	Karin Designs Ltd – an illustration from *Home Life with Cats* by Brian Aldiss, Grafton, 1992.
page 55	H. Blain/The Bridgeman Art Library.
page 60	Fine Lines Fine Art.
page 75, 97	Phillips Fine Art Auctioneers.
page 77, 117	Eye Ubiquitous.
page 89	The Mansell Collection.
page 121	J and S Antiques/The Bridgeman Art Library.